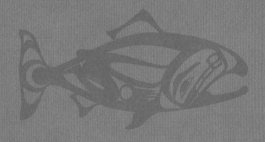

Spirit

TRANSFORMED

ALSO BY ROY HENRY VICKERS

Solstice: The Art of Roy Henry Vickers (1988)
The Elders Are Watching (1990, with David Bouchard)

Spirit
TRANSFORMED

A JOURNEY FROM TREE TO TOTEM

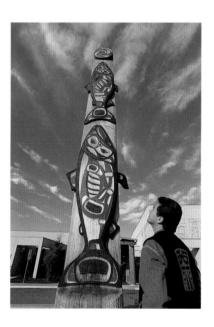

ROY HENRY VICKERS

WITH BRIAN PAYTON

PHOTOGRAPHED BY BOB HERGER

RAINCOAST BOOKS

Vancouver

FIRST PUBLISHED IN 1996 BY

Raincoast Book Distribution Ltd.
8680 Cambie Street
Vancouver, B.C.
V6P 6M9
(604) 323-7100

1 3 5 7 9 10 8 6 4 2

CANADIAN CATALOGUING IN PUBLICATION DATA

Vickers, Roy Henry, 1946 –
Spirit transformed

ISBN 1-55192-015-8

1. Vickers, Roy Henry, 1946 –. 2. Totem poles – British Columbia. 3. Indian
wood-carving – British Columbia. I. Herger, Bob. II. Title.
E98.T65V52 1996 731'.7 C95-911099-2

Designed by Dean Allen
Edited by Michael Carroll

Printed and bound in Hong Kong

To my wife, Rhonda, and to my son, William

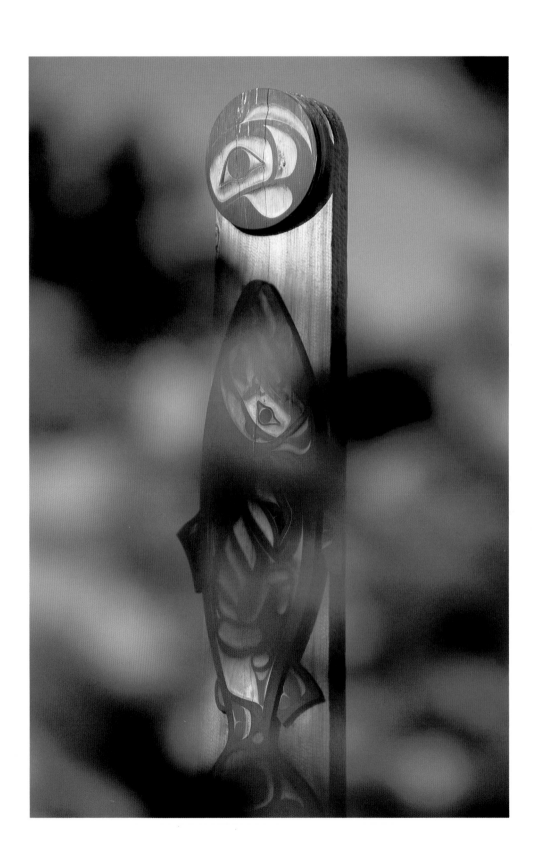

Contents

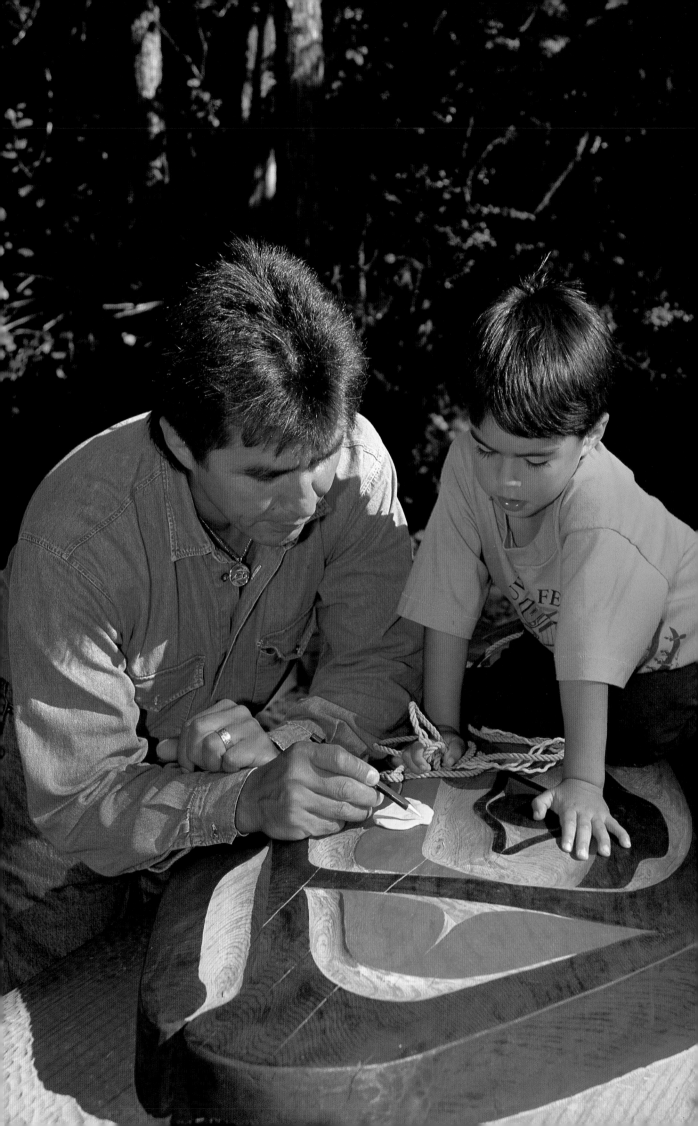

Preface

TALL, SHADOWY SCULPTURES are part of my earliest recollections. These are the totems of Kitkatla.

I remember climbing on one of the smaller totem poles that stood in the grass on a point of land in front of our home. I also remember a very tall pole that doubled as the village flagpole, and a mortuary bear pole of granite that stands to this very day. Later we moved to Hazelton on the Skeena River where I came to know dozens of poles, and then to Victoria, which boasted the tallest totem pole in the world. As I grew up, these sculpted forms continued to remind me of my heritage and, no doubt, helped to influence my decision to travel the path of the artist.

During 1994 I was given the privilege of carving a totem pole for Saanich Commonwealth Place. This book, through words and images, documents the process of creation . . . the journey from tree to totem.

In addition to photography, I have chosen to include four of my paintings to help depict this journey: *Kitkatla Winter*, *The Salmon Legend*, *The Salmon Moon*, and *The Watchman*. Together they illustrate some of the totems that I have grown to love and admire — totems that have inspired me.

Explaining the nature of wood grain and growth rings to my son, William.

I wasn't alone in the creation of the Salmon Totem. While in a project of this scope it is nearly impossible to name everyone who has helped along the way, this pole couldn't have been created without the support of certain people. I would like to thank my wife, Rhonda, and son, William; my parents, Art and Grace; my brothers and sisters; Henry Nolla; the staff of Eagle Dancer Enterprises; and the Pacheenaht, Ditidaht, Opetchesaht, Sheshaht, Nanoose, Nanaimo, Chemainus, Penelakut, Halait, Cowichan, Malahat, Songhees, Esquimault, and Tsartlip First Nations.

I would especially like to thank Bob Beard and Don McMullan of TimberWest Forest Limited, the company that generously donated the tree, transport for it and the finished totem, and $50,000. Their involvement in the Salmon Totem project was crucial.

Thanks also go out to Johnson Gordon from my home village of Kitkatla; Chester Moore from my birthplace of Lakalzap (Greenville); Simon Charlie, Denis and Philamena Alphonse, and Rod Modeste; Norman George of Songhees and Daniel Sam of Tsartlip for recognizing and acknowledging the pole raising on behalf of Chief Thunderbird; Richard Krenz, Tom Sampson, and Dan Henry; and Beth Dick and the Salish Nation Dancers, as well as the Solomon Islands Dancers.

I would also like to thank Mayor Murray Coell of Saanich for his faith and support; Campbell Moore Group Architects for its teamwork and dedication; and Bob Herger, Ken Budd, Togil Productions, and Lois Lane Communications. And a heartfelt thank-you to Brian Payton for making sense of my words.

Finally a very special thanks to everyone who volunteered to pull on the ropes in the traditional pole-raising method, as well as to all those who took the time to witness such a special event.

Through the process of creating the Salmon Totem, those shadowy figures of my childhood have come into sharper focus. It is my pleasure and privilege to share something of what I have learned.

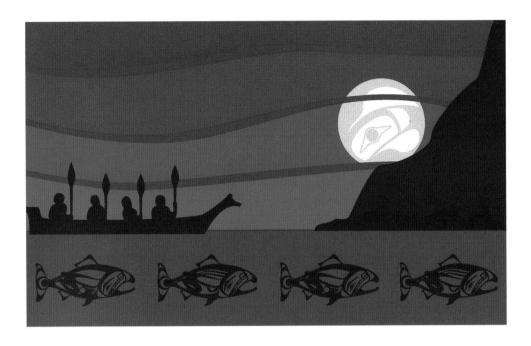

The Salmon Moon

*I remember stories from my grandmother about the moon of the
salmon, the time the salmon return to the river.*

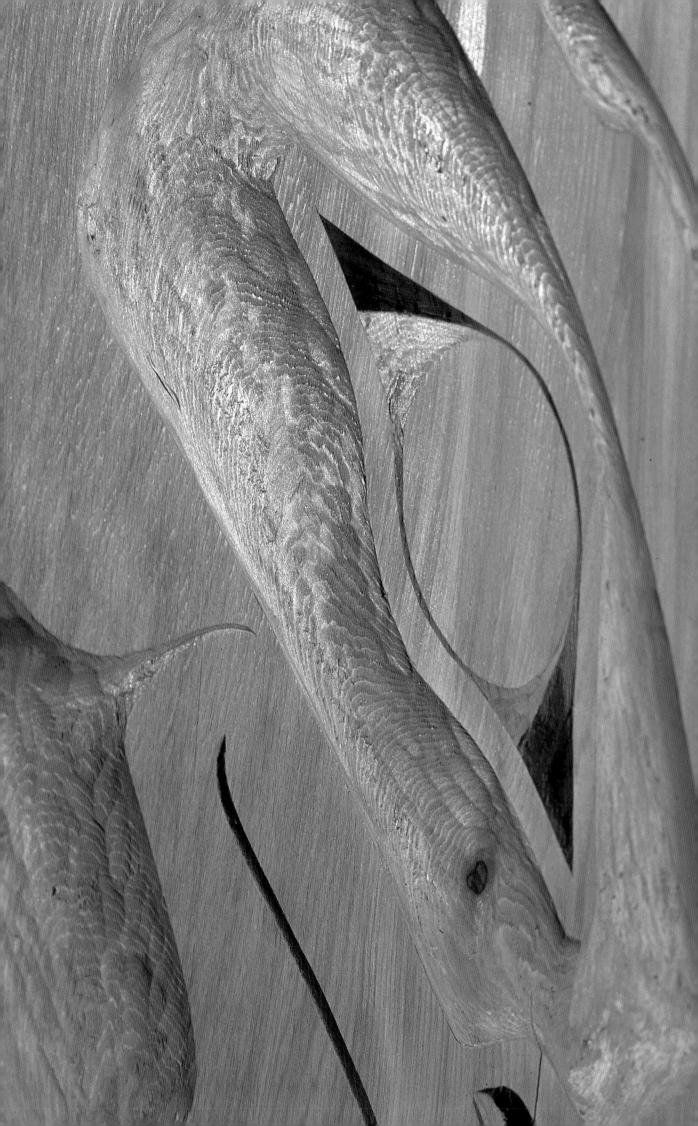

A New *Ptsan*

I have the inquisitive spirit of a child. Not only that, I have some of the knowledge

of my ancestors and elders. I want to bring some of that lost knowledge back into

my culture. I want to take the lessons I have learned and create totems that will

remind my children and grandchildren about the legends — and

bring those legends to life.

WHAT IS A TOTEM? Well, I am not sure what it is. The word comes from Europe somewhere. It seems the establishment has chosen to call the society of aboriginal people who have lived on the West Coast of North America for thousands of years a "totemic society," whatever that means. We know that the art form is more than 2,000 years old. In the Tsimshian language our word for a totem is *ptsan,* and that word is older than the knowledge of what it means. But *totem* is the term commonly used today.

Totem poles come in many forms: mortuary poles, heraldic poles, house poles, and ridicule/shame poles. Traditionally the totem was used to inform passersby about the people who lived in a particular village and what it was they had to say. The mortuary pole was similar to a tombstone, the heraldic pole was akin to a crest or a family story, and the house pole was used to hold up the beams

The eye of the salmon: an early stage in the carving of the
totem before paint was applied.

in a longhouse and tell the story of the owner, the chief of the house. As for ridicule or shame poles, today they only exist in museums. Such poles were commissioned by a chief to announce an unpaid debt, address a grievance, or express anything else that was worthy of shame or ridicule. When restitution was made, the pole came down. Whatever the type of pole, the main characters were always carved in a column on a cedar tree so that people walking by could look at them. And if they had knowledge of that village and the legends of the people who lived there, they would understand what the pole said.

A commercial pole is commissioned from a source outside the culture. More commercial poles are being done today than traditional poles and they can be seen in many different places. Yet even these poles serve a purpose in that they remind us of the traditions of West Coast aboriginal peoples.

The art of totem carving really flourished from the beginning of the 1800s until about the early 1960s. Perhaps the greatest outpouring of art on the Northwest Coast was during the mid-1800s when the people who lived here were introduced to steel tools and some of the technology the white man had brought. For aboriginal art, especially sculpture, this period was particularly productive.

Contrary to what some outsiders believe, the carvings on a totem pole are not a language to be read for exact meaning. You can't "read" a pole — you are reminded of the story by the characters on the pole. An example would be the Raven Legend, the story of the origin of daylight. This legend about how daylight was brought to the world by the raven is one that all Coastal Peoples share. In different villages up and down the coast you will see the same story told in different ways, in different languages and traditions. Unlike nomadic Inland Peoples, the Coastal Peoples were permanent residents of a particular area and had more time to devote to artistic endeavours. These other people, the Inland or "Stick" Peoples, as my grandmother's generation referred to them, lived in the woods (the sticks) and had other traditions. But not the totem pole. The totem pole belongs to the people of the West Coast.

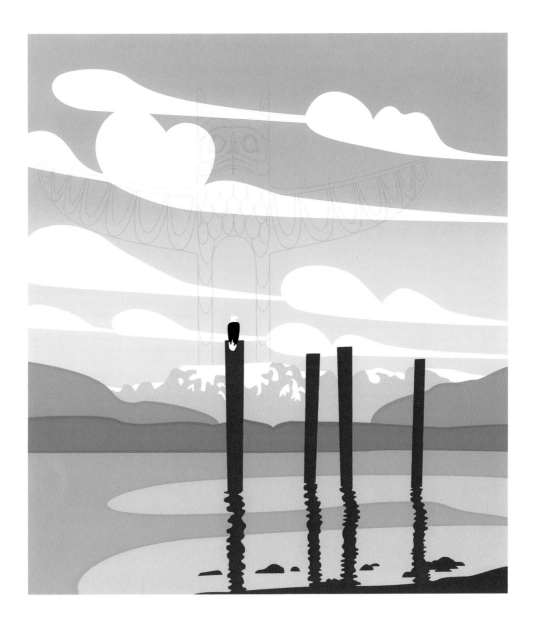

The Watchman

I heard the call of an eagle in the old Comox village site and found him perched atop a piling.
Eagle, the master of fishing, the patient one, the Watchman.

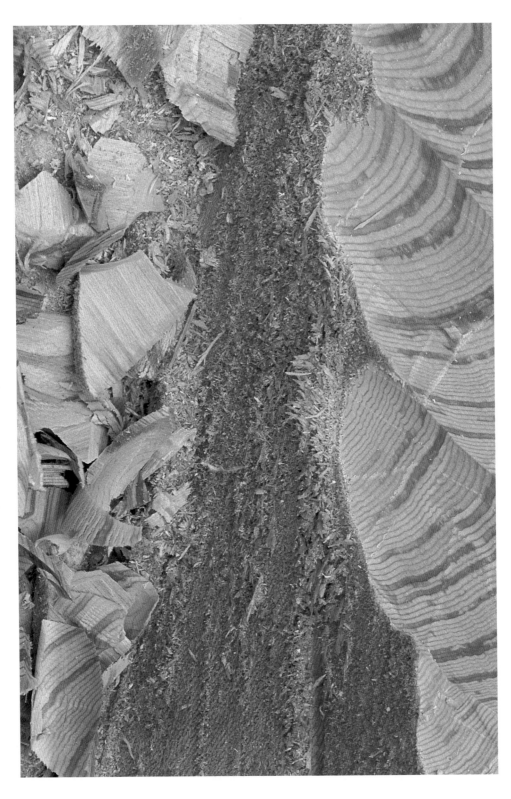

In everything there is beauty. Here the cuts made by an adze and the wood chips
that have resulted form their own abstract patterns.

I grew up in total ignorance of totem poles. I remember climbing on them as a child in Kitkatla, but their stories and significance weren't explained to me. I grew up watching them fall, one after another, and not be preserved. Doesn't anyone care? I wondered. Why just let them rot? Now I have learned that when totems fall it is meant for them to return to the earth. Their death helps other trees grow — just as we live out our lives, die, and follow the cycle of life. These days people have lost sight of the beauty of that cycle. Where is your head if you try to stop the progress of time? Despite all of our power, our bodies get older. It is sad when people pretend they are still young and deny the aging of their body, the beauty of growing old and dying.

My mother died recently. And while there is great grief from her death, I have actually "gained" her more now that she is gone. I am spiritually closer to her in her death than I could ever be in her life. It is like the death of those old poles. They are still with us like the spirit of our ancestors. So, as the old totems return to the earth, it is time for new work. It is time for new poles to rise in their place to help the people recover their sense of power — personal power that comes from the land and their ancestors.

When I was asked to be a part of the creation of Saanich Commonwealth Place, the aquatic centre for the 1994 Commonwealth Games in Victoria, and then asked to contribute a pole, I felt it was a great honour and a chance to pay tribute to my aboriginal heritage in a very important way. When I thought of the purpose of this structure — swimming — and the people whose land it is on, I was taken back to a time when I worked with Chief Dan George on a film called *Welcome Swimmer*. It is a beautiful story about the return of the first salmon to the Coast Salish people. From that early inspiration came the theme of honouring our elders. On the exterior of the building are large friezes depicting the faces of the elders from the five nations of the Coastal Peoples. In many ways these faces represent people like Chief Dan George, George Clutesi, my grandfather Henry Vickers, Robert Davidson, and his great-grandfather, sculptor Charles Edenshaw. As the artist, I am

paying tribute to the people who have been an inspiration to me all my life.

When it came time to create the Salmon Totem, I began thinking of the style
of the Salish poles. Most people are used to seeing Haida or Tsimshian poles. To
some, the Salmon Totem looks more contemporary, but it isn't. It is carved in the
ancient traditional style of the Salish. The traditional Tsimshian or Haida pole
is carved from the bottom to the top in detail, in a circle, or in a semicircle.
Traditional Salish poles are carved as though they have a back to them, like a
backboard. The figures are more realistic, which actually suited the way I wanted
to tell this story. At 30 feet the Salmon Totem is the largest and most powerful
pole I have ever carved.

As an artist, there is a real purpose to the gift I have been given: to show my
aboriginal ancestry. It is important for me to show others our struggle and to
work with aboriginal people to help them face the reality of their heritage, to
embrace it, and to come out the other side stronger than before.

Sometime ago I was working on a painting called *Kitkatla Winter*. In creating
that piece I thought of the long winter of our discontent, the winter of our pain.
I thought of the loss of culture, language, ritual, and ceremony. I thought of the
loss of worth and belonging, which are basic human rights. I thought of the dam-
age done to our culture by white men who came here — white men who are also
among my ancestors. I was left with anger and pain.

But after I finished that painting there was a transformation in my life. Today
I am filled with an overwhelming passion to bring the preciousness and beauty of
the culture that created those poles back to life — for you, me, my children, and
their children. The honour, respect, and desire to be closer to the totems from
another era have helped me to join the ranks of many carvers in British Columbia
who have resurrected a culture, who have made it through the long winter. That
is the spirit that carried me through the creation of the Salmon Totem.

I carved my first pole, an owl, at Ksan back in 1974. I have carved dozens since
then and have always featured them in my paintings. I have painted the great

totems in the land of my childhood in Kitkatla and Skedans, perhaps the most famous of all the heritage sites, as well as in Kitwancool, Kitwanga, Kispiox, and Hazelton. I have studied the paintings of Emily Carr and Langdon Keene. Yet never in all that time did I consider that it would be possible for me, Roy Henry Vickers, to be the creator of a pole as powerful as these — as powerful as the Salmon Totem.

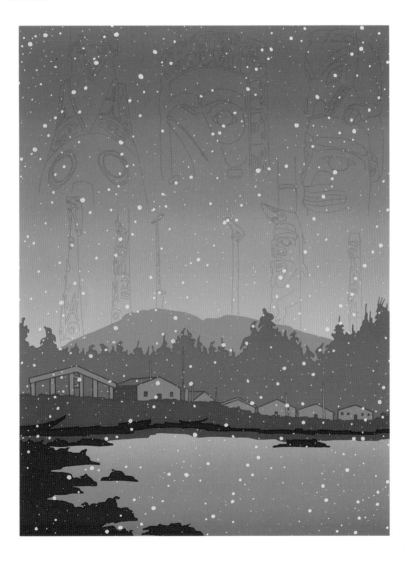

Kitkatla Winter

The village of Kitkatla existed before the Egyptian pyramids were erected and continues today after more than 5,000 years.

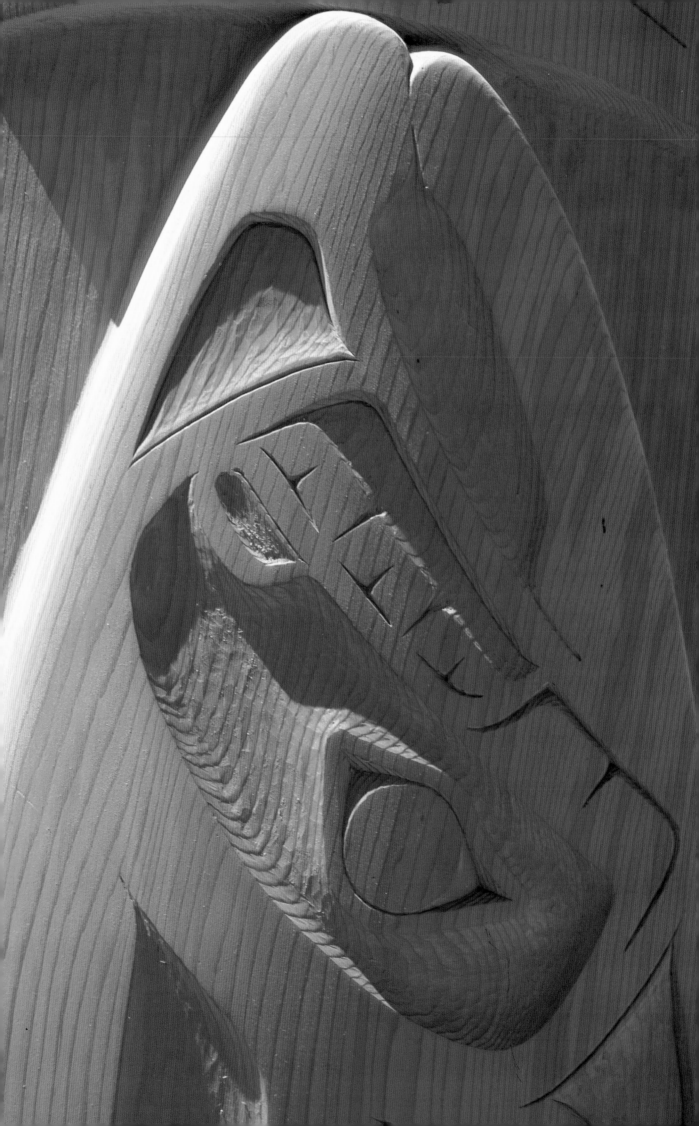

The Salmon Legend

*All the time that it took for the knowledge to come to us of how to walk on the face
of Mother Earth — eons, thousands of years of knowledge in art and design — are
captured in the creation of one piece . . . the Salmon Totem.*

THE INITIAL SKETCHES of the Salmon Totem were inspired by the legend of
the salmon and their return to the West Coast each year. The principal characters
are a man and woman, a brother and sister, salmon and the moon — the moon of
the salmon that comes each summer.

Each of the units of time we call "months" today are known as "moons" by
indigenous peoples. I remember stories from my grandparents about the moon
of the salmon, the time the salmon return to the river; the moon of the popping
trees, which speaks of the middle of winter when it is so cold that the trees crack
and pop; and the moon of berries, May, when the salmonberries come out.

The Salmon Legend was first told to me by the Salish people. I remember the
legend speaks of a young man who is lost to his family and village. His sister goes
to the seashore day after day and mourns the loss of her only brother. Eventually
the Great Spirit, or the Chief of the Heavens, speaks to her through her mind and
heart and says, "Your brother is fine. He is part of the Salmon People now and

*The lines of time, grains of cedar, and the
salmon emerging.*

lives in the ocean." The sister asks the Great Spirit, "Can I see him? Can I be with him?" Her request is granted, but in order to see him she must also be turned into a salmon. She agrees. This transformation takes place over a period of time and finally she gets to enter the ocean — on the condition that she must return to the land or forever remain in the ocean as a salmon.

The reunion with her brother is a very joyous event. But after days of enjoying his company the time comes to make a decision: either return to the land of her people or stay in the ocean with her brother and remain a salmon. She decides to stay. Although they become part of the Salmon People, the brother and sister never forget their Salish ancestors. And the legend has it that each year, during the moon of the salmon, the brother and the sister bring back to the Salish the generation of salmon that spawned four years earlier and, in that way, sustain their ancestors forever.

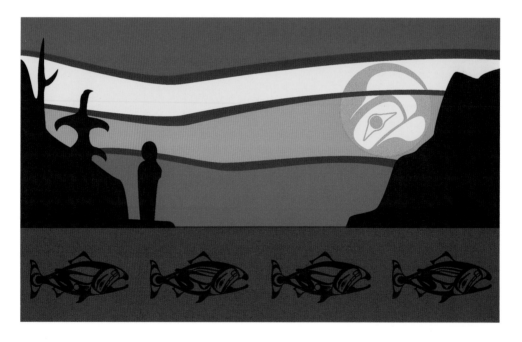

The Salmon Legend
There is a story told . . .

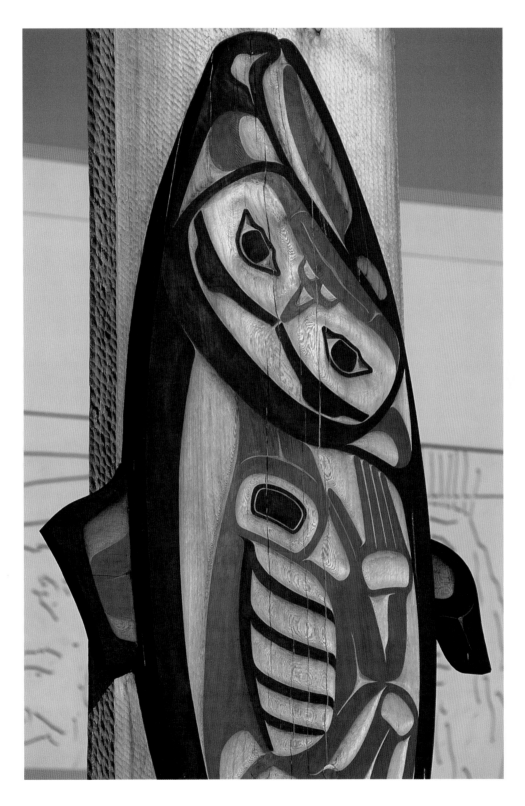

Brother Salmon: "the legend speaks of a young man who is lost to his family and village."

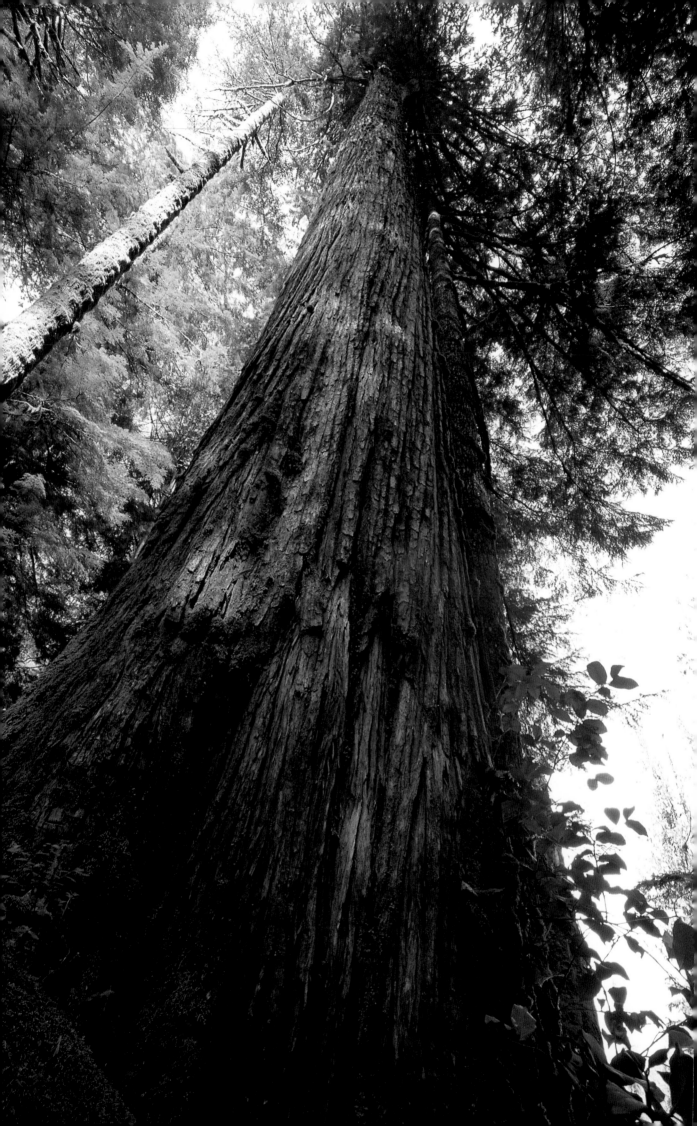

The Secret Life of a Tree

I remember the words, "Let the spirit of this tree, let the time that it took for it to stand here, help the carver . . . help the man whose time will be spent creating a new life and new image from you." Those words inspire me now and will inspire me always.

WHEN WE WERE ready to go and find a tree, we thought of the more tradition-al way a tree is taken. I thought of how I felt about killing an 800-year-old cedar and how there must have been a traditional way – an honourable, respectful way – of taking the life of such a beautiful living thing.

Walking up to that giant in the forest, standing there and looking at it, seeing the straight grain, seeing that this was *the* tree, was a mystical feeling. It is difficult to explain. It was as if my ancestors were standing behind me, saying, "This is the one. This is the tree that will bring out the good and true and beautiful in our race."

We found the tree in the traditional territory of the Pacheenaht people in the Walbran Valley on Vancouver Island. We went there, not assuming we were going to receive permission, but with respect and humility, ready to come away with whatever we got. We looked at a number of different trees in the area, and when the Pacheenaht people who were with us came to the tree that we knew was the one, they knew it, too. There was a bond that formed and that bond was one of

The cedar in the Walbran Valley that gave up its life.

26

knowledge – both an intellectual knowledge and a spiritual knowledge. It was a beautiful thing. It was our desire to reach out to the people on whose traditional land the tree stood and ask not only for formal permission, but also for a blessing or some respectful tribute to the tree for its life.

Each tree is like a human being; it has its own personality and uniqueness. And all of the inspiration that the artist receives comes with the knowledge that this giant that lived for hundreds of years is giving up its life to tell a story to the people. Not only will the inspiration bring out the good and true and beautiful tree, it will also bring out the good and true and beautiful in the artist.

We were delighted to discover that the Pacheenaht had a ceremony, which was performed in the forest while the tree was still living, at the place it had stood its entire life. It was beautiful. The ceremony was like a funeral. There was no celebration; it was a very sad time. The Pacheenaht said that there are two reasons we take the life of a tree. One is for a canoe, which is used to transport people in different ways – not only to move them physically, but also spiritually. The other time a tree is taken is to carve a pole.

When I heard the voice of the man and woman who said the prayer and spoke to the tree, and when I thought of the lives that they have had and the pain they felt during the ceremony, it confirmed in me the belief that we should always give respect to every living thing around us. Somehow, some way, we have to respect and love the land we live on. We must extract only what we need to support us – not what we *want,* but what we *need.* So we must change and we must learn from those who have lived here for thousands of years before us in peace and harmony. And we can do it.

The act of respect for people on whose land we walk is something we have lost for generations. It is something that the white man needs to learn. I am half white and it is something that the white man in *me* needs to learn, as does the Tsimshian, the Kwakiutl, and the Haida man in me. My ancestors, both on my father's and mother's sides, have something to do with the way I walk, the way I carry myself on

"Each tree is like a human being; it has its own personality and uniqueness."

the face of this earth. So if I learn anything from this experience of the Salmon Totem, from this journey through the ages of time, let me learn the lesson that when I walk on this earth — whatever part of the land I walk on, whatever creeks I cross, whatever piece of ocean I am on — there is someone whose lineage and whose family has been given the responsibility of looking after it.

To give respect to something that is living, in order to impart more knowledge or more life to the society we live in, is a privilege. That feeling was brought out in me and will stay with me for the rest of my life. Giving respect to that which gives up its life so that others can live is all that is asked of any of us. That feeling comes out of the death of a forest giant. It is a beautiful thing.

There was a time when all this could have happened and I wouldn't have been touched. I wouldn't have gone through the process of dealing with the feelings and emotions, honouring the moment, respecting myself and everyone around me, respecting the tree and the person who cuts it. To see people who felt the same way, to look around in that forest before that tree came down and see many different people standing in honour and respect, is an image that will stay with me until I become part of the earth.

I thought of my friend Chief Dan George many times while carving the Salmon Totem, and when I did, I was taken to a place where I could hear him, see him, and feel his gentleness. I remember him once saying, "Those whose lives are lived in the forest, close to Mother Earth, know the secret life of a tree." Those words helped me when I worked on the Salmon Totem.

Everything that sustains our lives comes from the earth. Something dies every day and many things die in order to sustain the life of a single human being. To pass through this life and not know that is a tragedy. We must be in touch with death and dying. How much more we can enjoy our life when we know that one day we, too, will be gone! We will return to the earth. So, really, we are part of the trees, we are part of the grasses. The blood in our veins is part of the rivers and creeks. The sadness of death becomes part of the joy of being alive.

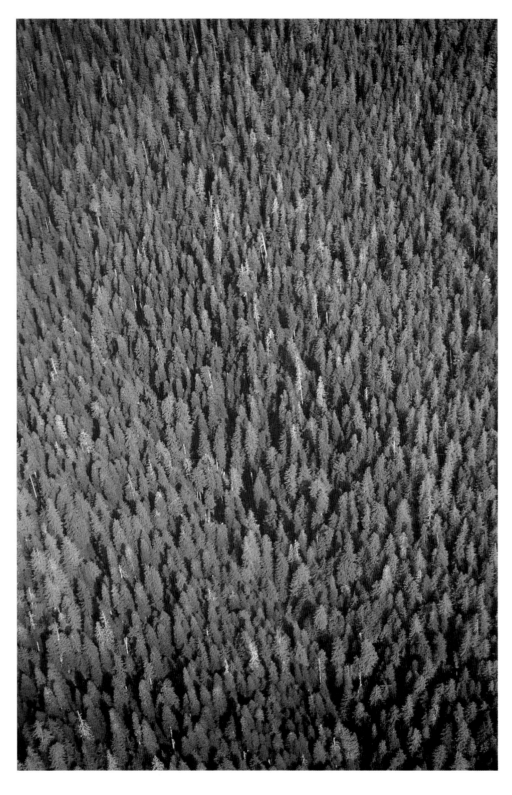

Millions of life-years in the Walbran Valley. The cedar that became the Salmon Totem once stood among these majestic trees.

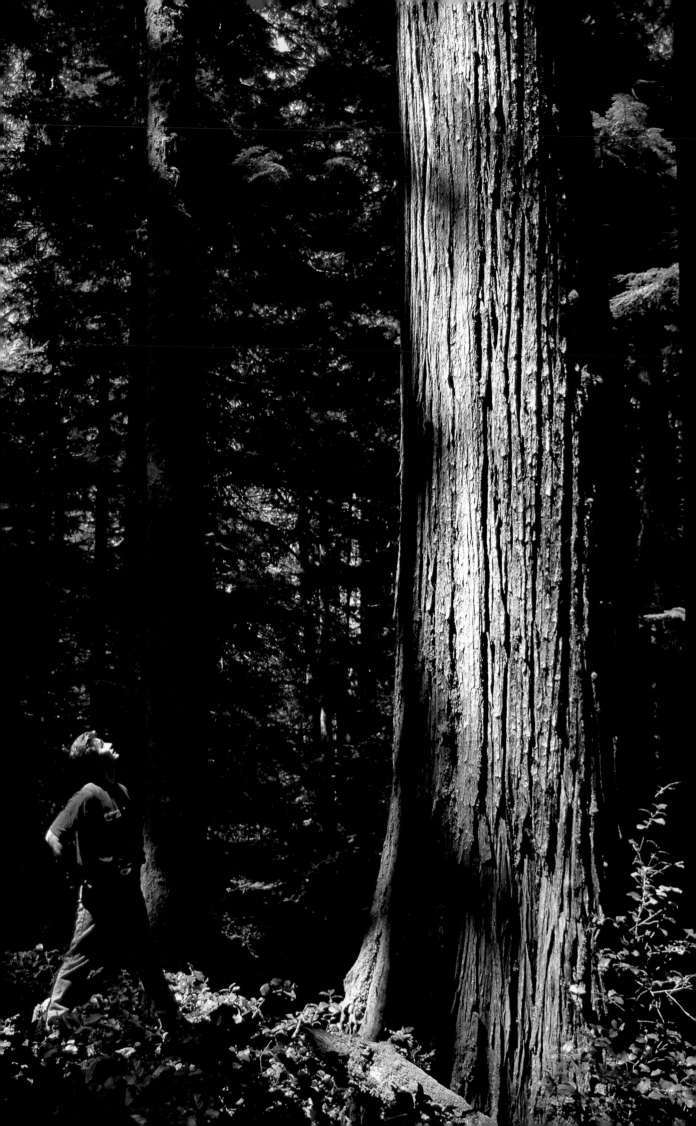

A Reverence for Wood

When the wood is drying, it splits and you can hear the cracking sound. Knowing
that it is a natural process is comforting to me. I don't want to fill it with putty
and paint over it and pretend it's not there. It is part of the whole cycle. It is part
of life. It is like us — growing older and getting cracks and crinkles
in our face. It is wonderful and it is beautiful.

WHEN I WAS a young boy in the village of Kitkatla, I had the good fortune of
being able to watch men in the area working in wood — everything from my
grandfather carving a canoe to the neighbour four houses down in his boat shed
building a beautiful seiner, plank by plank, out of wood that he had cut. So wood
has been part of my life from my earliest memories.

When I smell yellow cedar, I go back to when I was four or five years old, stand-
ing there watching Jimmy Nelson, one of the chiefs of Kitkatla, working away on
his boat. The smell of yellow cedar is transforming to me. It takes me to another
time — so long ago that it seems as if it were someone else's world — and yet the mem-
ory is so sharp that it seems as if only a couple of years have passed. So, for me, the
love of wood has developed in my very nature, in the smells, the feel, in the visual
impact of poles I was around when I was a child. It has always been a part of my life.

The forest is like a cathedral of nature
in which a certain reverence for trees
should be maintained.

32

The first cut we made in that cedar was done with a huge chain saw. This cut is very important. There is a saying that the first cut is the deepest, and when you are working with a cedar tree, it is the deepest and it is also the most important.

When you cut a tree, if you cut it smoothly enough, you can see the annual growth rings working their way from the beginning in the centre to the end of the tree's life on the outside. On a tree you can sometimes count the rings in an inch of space and find 100 years. Then there are other places where there are 25 years in three inches. You find times when it grows faster and times when it grows slower. In between the growth rings is very soft wood.

When you are cutting with a knife and "moving wood," as we say, moving it from one place to another, you move with the grain. There are areas that are soft and areas that are hard. That is how the wood helps you move through it. It helps control how your knife moves. If you work against the grain, against the nature

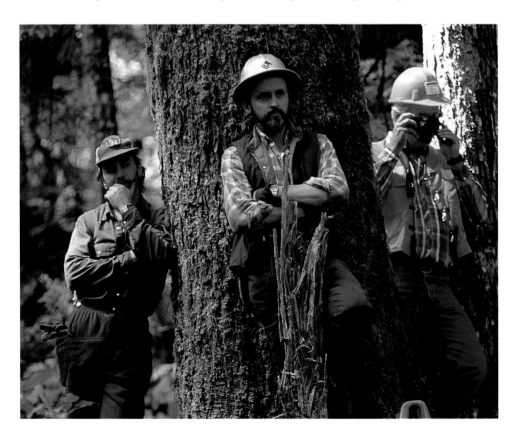

Above: *On Tuesday, May 25, 1993, members of TimberWest's Gordon River crew travelled to the Walbran Valley to fell, buck, yard, and transport the yellow cedar I had selected for my Salmon Totem.*

Right: *The feller saws a wedge in the tree so that the crew can control where the tree will fall.*

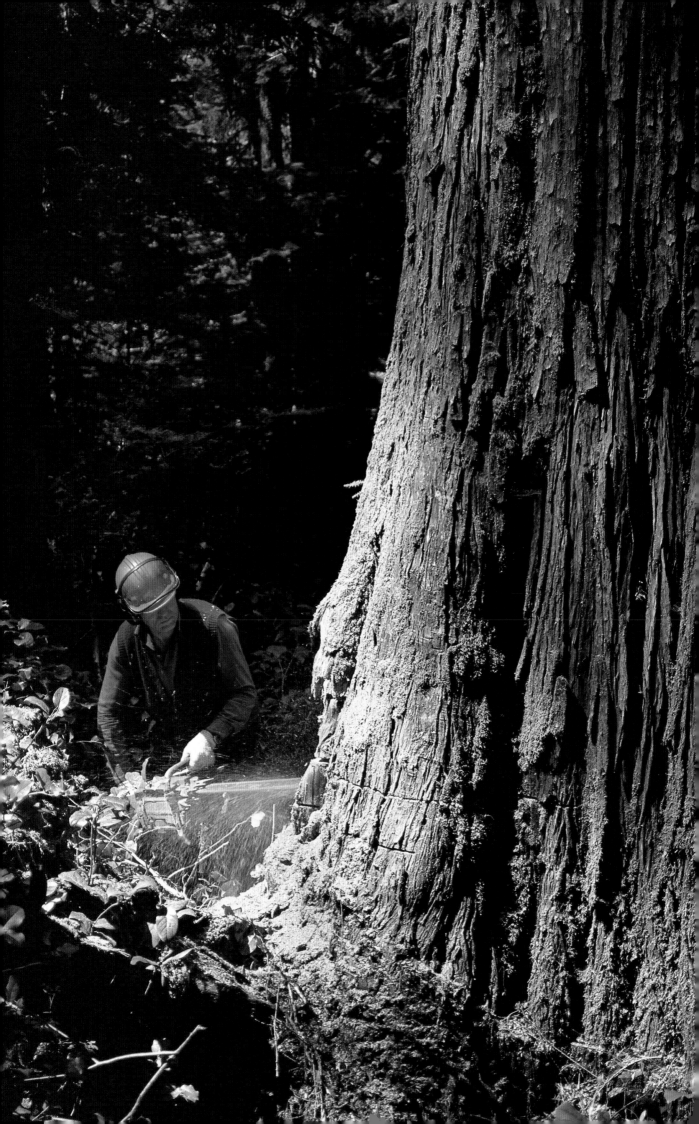

34

of the tree, it will pull your knife into an area you don't want to go and you will cut a piece of wood that you don't want to take away. So it is a powerful analogy for life and living. That is why it is so therapeutic. It helps you to see, to feel, to be more the person that you are supposed to be because it is taking you through the growth rings of your own life. It is taking you through hard areas of slow growth and soft areas of more rapid growth. It helps *you* to move. It is amazing.

I am reminded of how I deal with a knot when I am carving. What am I supposed to do with a knot? Drill it out and plug it? Make it as if it weren't there? Maybe. But I choose to leave it. There is a knot on the Salmon Totem, just below and to the left of the moon, and I still don't know why it is there. But it is there and it is beautiful. It becomes a part of the design because it is a part of the personality and character of the tree. It looks good. I like it and most people seem to like it. What can I say? I love knots.

I am often asked what I do when I make a wrong cut or some other mistake. In the past I tried to evade this question the way a politician would. Today I really believe that there aren't any mistakes. Nothing is a mistake. I don't believe that there is a right way to do something or a wrong way. I believe that what is happening is what is supposed to happen. Everything happens for a reason and it is up to us to find out what that reason is. It is much easier to live this way. It is much more therapeutic. It takes you to a different place. It gives purpose to everything that happens to you in life. It helps you to see yourself and everyone around you.

When I carve, I am in a different time and space. I remember Bill Reid once saying that he could feel the presence of his great-grandfather around him when he was carving. This was a number of years ago when I was younger and bolder and more opinionated about things. I thought then, C'mon, Bill, you're leading us on just a little too much. He wasn't, though. Not at all. When I am carving, I can hear my grandpa and I can feel him. It is a beautiful thing. It is that feeling of ancestors being there, supporting you, helping you to move wood.

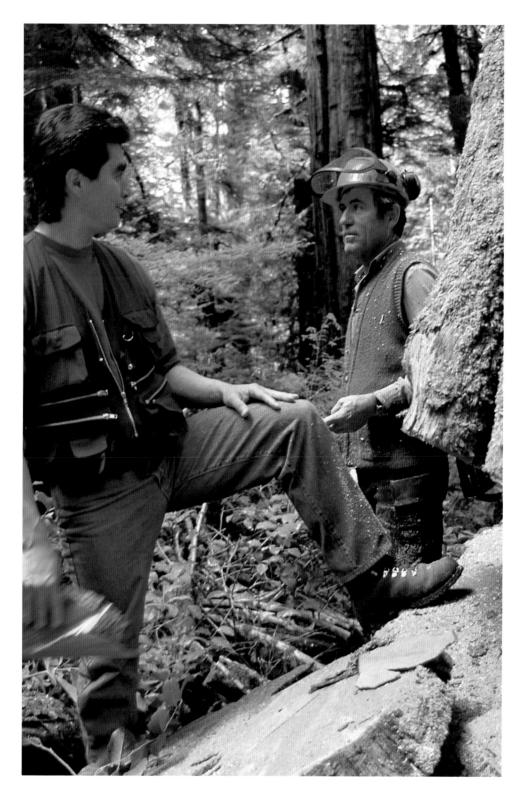

*Here I am talking to one of the TimberWest fellers. The wedge cut is
finished and the tree is still standing.*

Following pages: *After 800 years the great cedar falls to its mother, the Earth,
only to rise again as the Salmon Totem.*

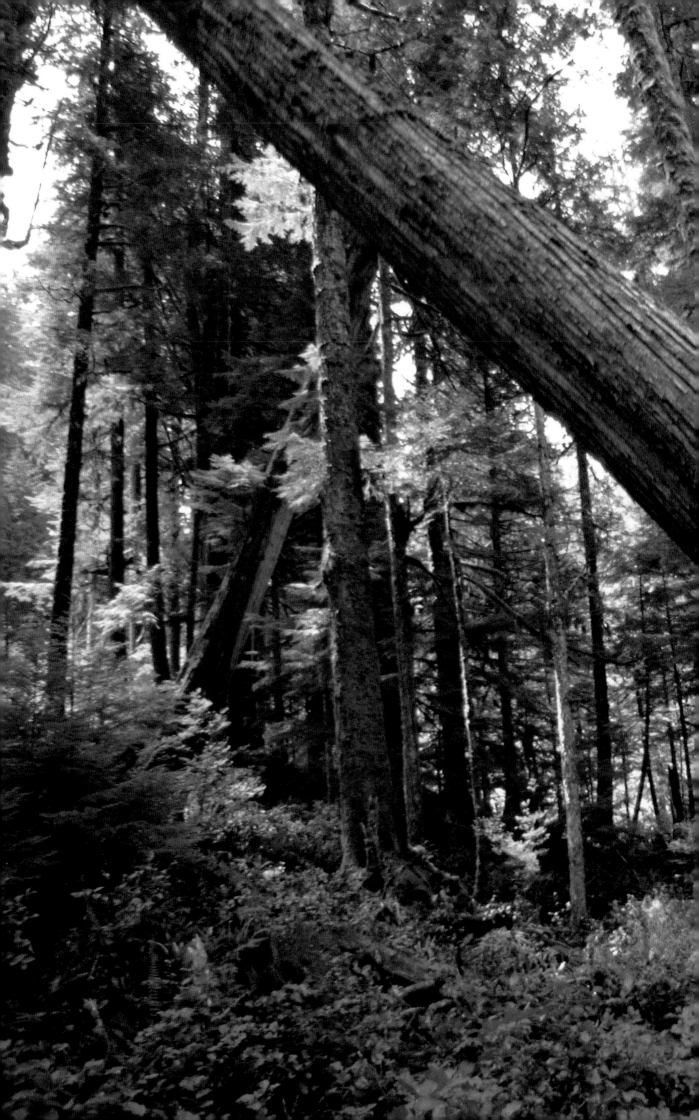

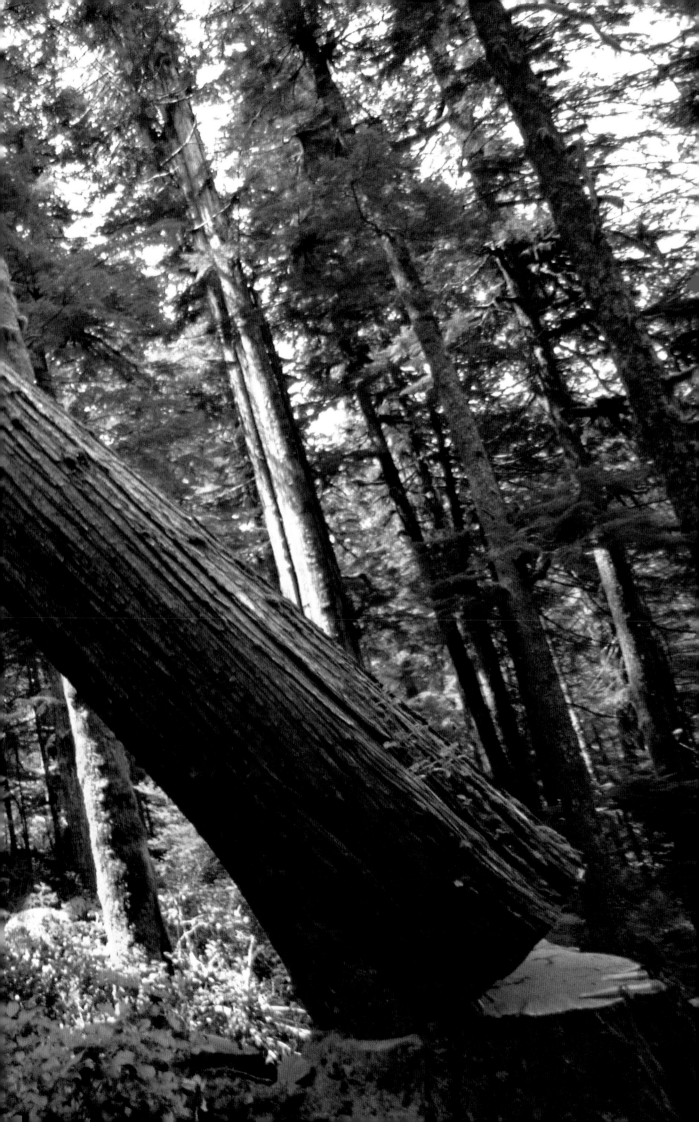

When I think of the different people who move wood, sculptors who have been an inspiration to me, I think of Henry Hunt, a carver who worked at the B.C. Provincial Museum. He really encouraged me to pursue my dream and my vision as an artist and a carver. I carved with him. It was also a privilege for me to work with Chief Dan George. I still remember different stories and ideas that come to me at the age of 50 that were planted at the age of 28 by Chief Dan George. The effect of one person can be very strong.

I remember Dan's thoughts on the beauty of the world around us and how, if we concentrate on Mother Earth and what she has for her children, we can soar on the wings of eagles and rise into the heavens: "The beauty of trees, the softness of the air, the fragrance of the grass speak to me. The summit of the mountains, the thunder of the sky, the rhythm of the sea speak to me. The faintness of the stars, the freshness of the morning, the dewdrop on the flower speak to me. The strength of fire, the taste of salmon, the trail of the sun, and the life that never fades speak to me . . . and my heart soars."

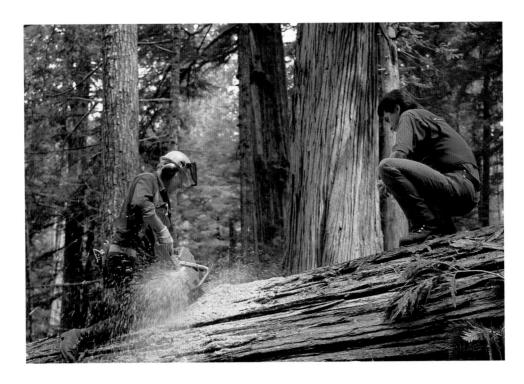

In order to transport the tree it must be bucked into
sections — the transformation begins.

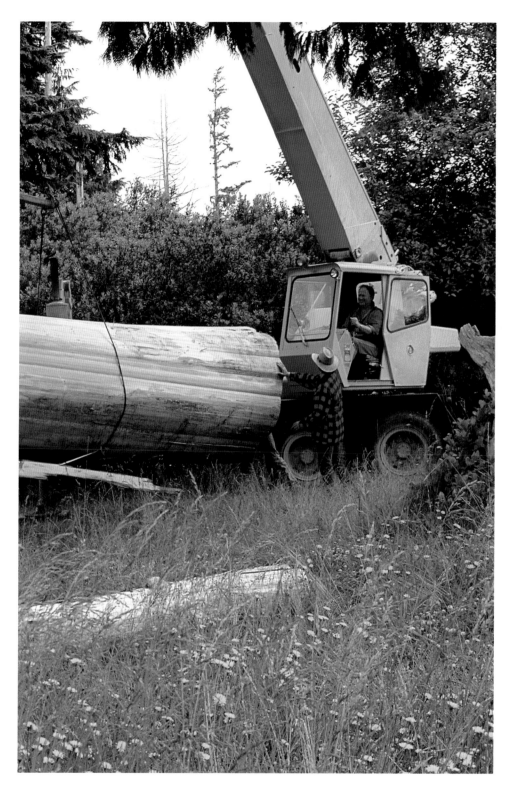

*Here, in Tofino, where I carved the Salmon Totem, a crane
operator lowers the log that I will use.*

Following pages: *Henry Nolla* (centre), *a TimberWest worker, and I guide the log
onto its temporary resting place in Tofino.*

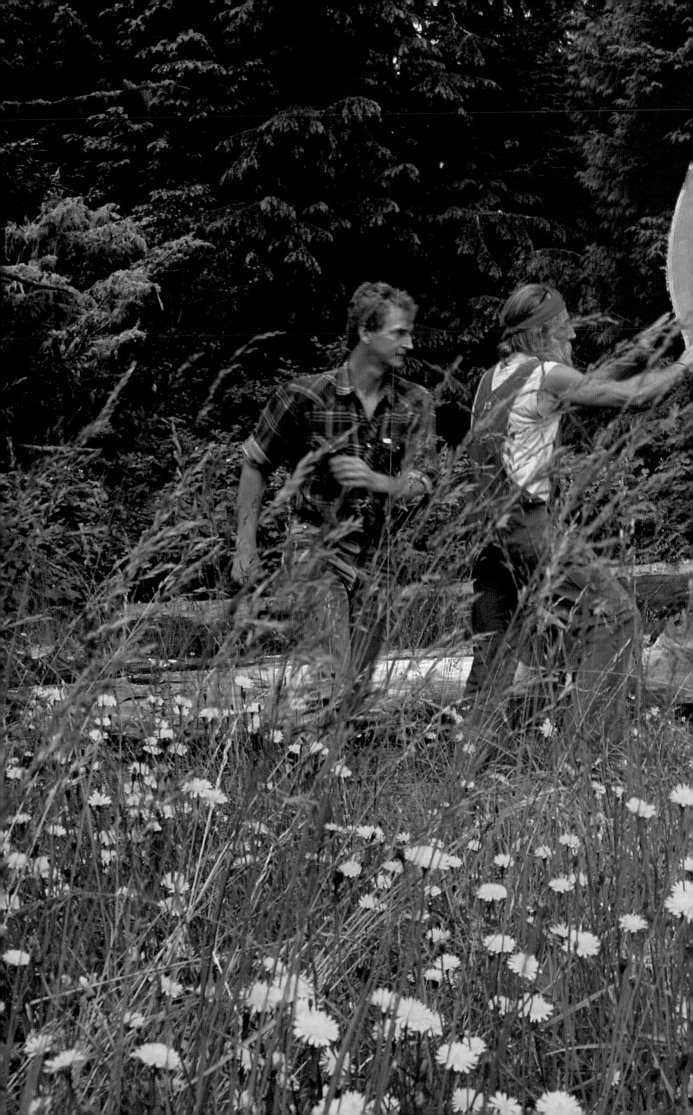

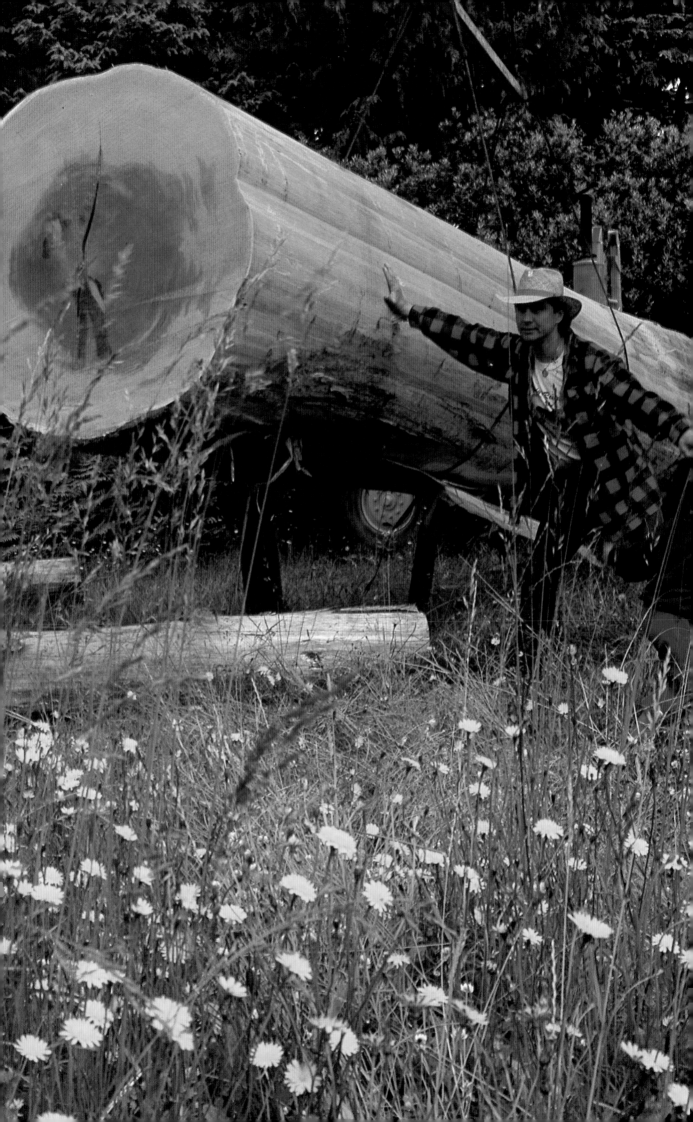

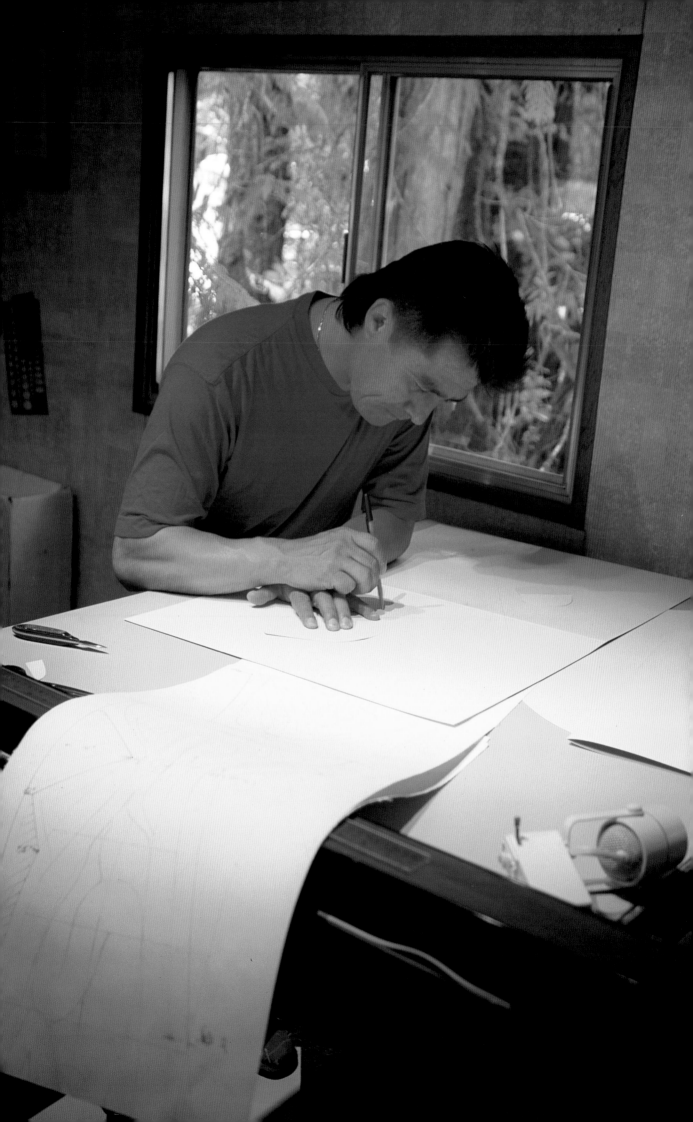

The Image Maker

When I am designing or painting, I am an image maker. I am teaching and
working from a place that is spiritual. When I carve, I am in a different space. The
wood guides me and helps me to move. I become a warrior, a healer,
and a visionary. These elements reside in each of us.

WHEN I BEGAN to design the Salmon Totem, I thought of male and female. I
thought of my ancestors standing behind me — my male ancestors on the right
and my female ancestors on the left. I thought of the male and female salmon. In
my mind, gradually, the image began to form of two giant salmon and the moon
of the salmon. In the traditional way of depicting animals, aboriginal people
illustrate the mystical connection between the human animal and all other ani-
mals on the planet. We human beings have the ability to create, as our Creator
does, and we are set apart from all the other creatures that live on the earth, in
the ocean, and in the skies by that creative ability. As indigenous people on the
West Coast, we pay respect to all other life forms through our creativity.

To illustrate this connection I wanted to show the male salmon with the
form of a man's face in its head and the form of a man's body in its body, and
likewise for the female salmon. This also illustrates the transformation of the

My Tin Wis studio in Tofino, where I designed the
Salmon Totem, with the help of my ancestors.

brother and sister in the Salmon Legend. I saw the female salmon above the male going toward the moon, the Salmon Moon, at the top of the pole. On traditional poles women are shown with a decoration, a "labrete," in their lower lip. This feature was common among Coastal Peoples prior to European contact. So on the Salmon Totem I have shown the woman with a labrete and long, flowing hair.

I made a scale drawing of the pole and carved two small models. Then I made and placed templates on the full-scale pole where I wanted them to be. I laid out a grid on the pole with lines every 12 inches and I marked out the back and belly of the salmon and then drew in the main curves to create the shape of the salmon's body. Once that was done we went to work with chain saws and cut out the big pieces of wood, leaving the rough shape of the salmon. Then we refined the shapes and continued the process.

After that, I placed everything I had drawn onto the pole and took a straight-edged knife, made cuts, and began removing the fine wood. What I was left with

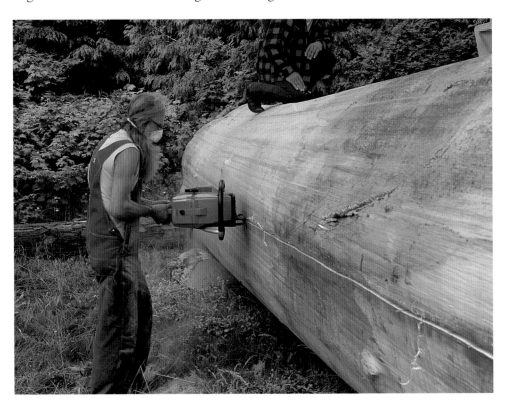

Henry splits the tree in half with a chain saw.

Here I have drawn the design in sawdust. The beauty is all there.

were form lines that created the salmon and the humans — the shapes inside the body, the eyes, nose, and mouth. When I stepped back and had a look at what I had done, I was amazed to see that it was what I had envisioned in the first place.

I am not sure how that works, but it does, and it is always a delight and a surprise. The little boy who used to smell the cedar and watch his grandpa carve and be amazed was astonished that he could do such things, too. And it is a great pleasure to know that some other young person may come along and watch me and perhaps be amazed, and that one day that same person may also be surprised by the act of creation. That is really what it is all about. That is why I do it: to teach, to impart, to see somebody else take the ball and run farther than I have, farther than I ever could have.

I remember my art teacher. One day we were talking about creativity and design and he said, "It's wonderful to be able to teach you and know that it's possible that you will be a far better artist, that you will carve more, create more, and say more than I ever could in my life." I recall looking at him and thinking, I don't think so. You're my teacher. I'm your student. How could that ever be possible? Now I find myself saying the same things to many young people, and people my own age, who are learning: "You know, if you work hard enough, if you apply yourself, you can do this. You can do more than this. You can bring out your own goodness, your own beauty . . . your own true self."

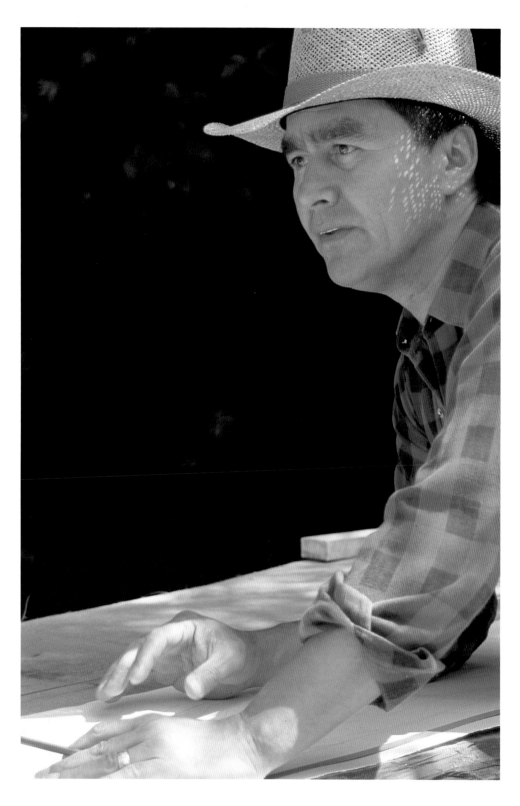

To find the exact centre of the log the designer must use a plumb line,
which can be seen here near my right hand.

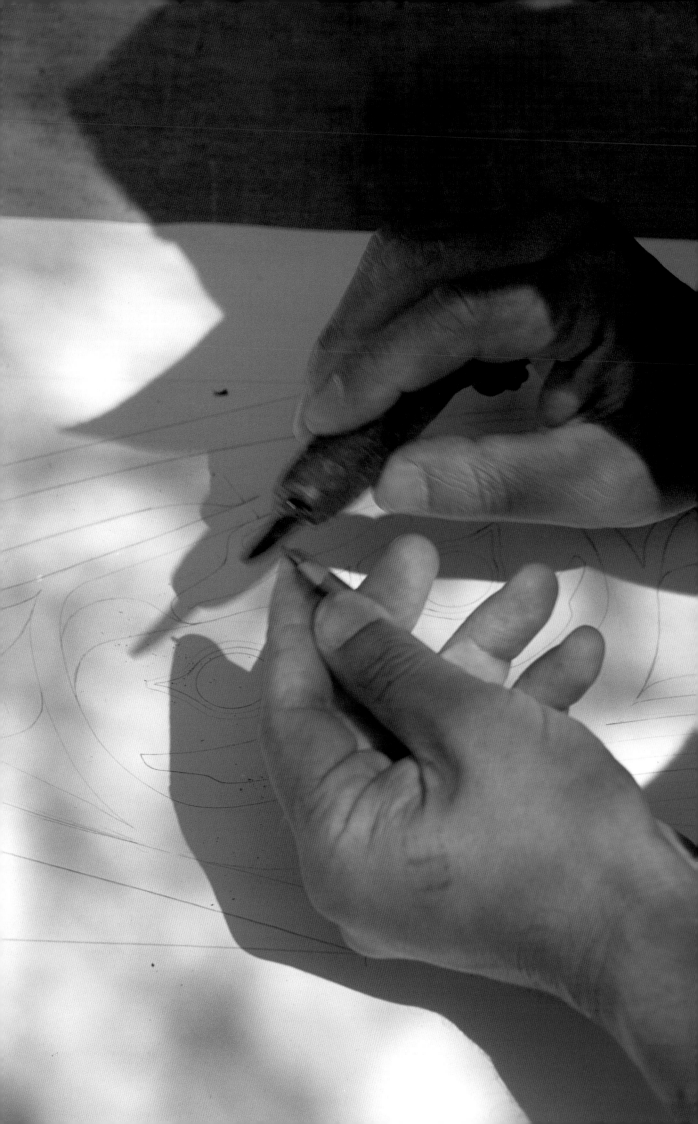

Shared Vision

*Henry is like a dream come true. We have been carving together for 15 years, and
over that time, somehow, he has held me stable. There is a philosophical bent to
Henry. He doesn't say a lot, but when he has something to say,
he usually hits it right on the nail.*

I FIRST MET Henry Nolla in Victoria back in 1973, right after I returned from
my first year of art school in Ksan. I liked him when I met him. He was carving
European sculptures of bowls, spoons, and ladles at the time. After that first
meeting, I never really expected to see him again. Then, when I wound up in
Tofino in 1980, I walked into a store and saw a small hand-carved bowl. I walked
over to it, looked on the back, and found his initials. When I asked the store-
keeper where she had gotten it, she told me that Henry lived and carved right
there in Tofino. As she was saying these words, as if on cue, in walked Henry. It
was amazing! We had a coffee and talked for a while and were excited to meet each
other again. He convinced me to stay in Tofino and asked me to teach him how
to carve poles. Henry even helped me find a place to live. It was only a quarter
mile down the beach from his place. That first winter we spent a lot of time work-
ing together, Henry and I.

*Keeping my pencil sharp while I work on the
white template of the design.*

We have worked together for so long now that Henry has become like an extension of myself. If it hadn't been for Henry, I don't know where I would be today. He is an accomplished sculptor, but he can't get into my mind. So there are some things I need to explain. There are times when we work together, when we will talk and philosophize, and then there are times where all you will hear is the *wishhh . . . wishhh . . . phoooo!* of the tools and our breaths blowing the chips away. We can be one or two feet apart and say nothing for an hour and a half, each into the spirit of working the tree and the wood. It is a wonderful experience and a great privilege to be able to work with someone like that. Working with someone I have confidence in is a real treasure.

When we are looking at a tree, a huge tree, what we try to do is see what we want that tree to be as a sculpture and then eliminate everything that gets in the way. We remove all of the wood that doesn't belong there until what we are left with is what we originally saw in our minds.

When it comes to moving large amounts of wood, Henry is the engineer. He

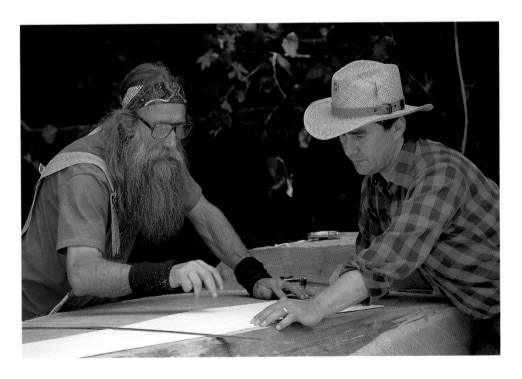

"We have worked together for so long now that Henry
has become like an extension of myself."

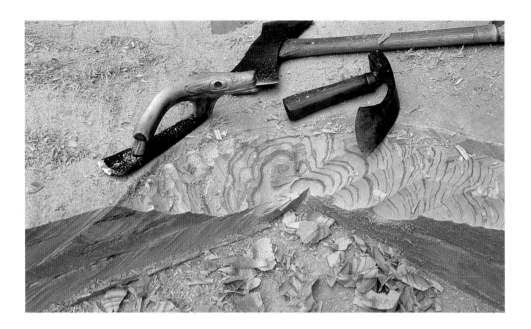

Tools of the trade: (left to right) *a D adze, a double-headed axe, and an elbow adze.*

has a natural way of doing things. He likes to get into the thick of it and have chips and sawdust flying in every direction. I set the vision, design, and take care of the fine work, carefully moving a little bit of wood at a time. We work in a very nice balance, Henry and I.

I work on many different projects at once – a new painting, a blanket design, or a pair of doors – and sometimes I need to leave Henry for three or four days at a time. When we were doing the Salmon Totem, I was able to walk away and he would continue to work on the pole. To be able to do that and trust his judgement is an honour and a privilege. The ability of two people to work with one vision is exciting. Henry says he has learned to trust my judgement and creativity. I know that I have learned to trust him. I suppose you could say we have developed what is called *kul-m-needsk,* which means "both looking as one."

Years ago, when Henry and I were carving, both tourists and locals would come by and ask, "What sort of tools are you using? Are they all traditional tools?" All aboriginal artists have to deal with this sooner or later.

We do work with hook knives and adzes, but we also work with chain saws and computers. I admit there was a time when I felt guilty about this. But we are in the 1990s now, not the 1890s or 1790s. These are the tools of our time, and we utilize them for our traditional art just as past generations used the technology available to them. The reason the art flourished in the mid to late 1800s was because steel tools were introduced. The indigenous people of the West Coast have always adapted to technological innovation. Had it not been for the steel and the new technology, the art form as it exists today wouldn't be here. People would be chipping away with stone mauls and antlered knives and the output would be greatly diminished. I love to work on computers and I am thankful for chain saws.

I think it was 13 years ago or so that Henry and I carved our first pole together. I still have that one. Back then Henry used to work exclusively with huge adzes, the kind the Swedes, his ancestors, used. That was the only way he wanted to move wood. He didn't want to use a chain saw at all. Today, when I watch him with a large, medium-size, or small chain saw, I always go back to those early memories of him swinging away with his adze. So both of us have been able to compromise. And with our compromises we have learned more and are able to do so much more than we could have when we first started.

Culture changes, and it isn't necessary for us to do things the way they were done in the old days. We do them the way we are supposed to do them today, the way we feel is right and good, the way we feel is true and beautiful. To me, it isn't important what tools you use. What is important is what you are trying to say, how well you have said it, how close to your own truth you have come in creating the piece you are carving.

Tradition has it that when you are finished carving a totem a pole-raising ceremony should take place in which the carvers tie their tools around their necks and dance. When I told Henry this before we completed the Salmon Totem, he wondered how we were going to dance with three chain saws and a computer around our necks! I told him, "We'll figure something out. Whatever the case, we'll dance."

Moving away what does not belong
with the swing of the D adze.

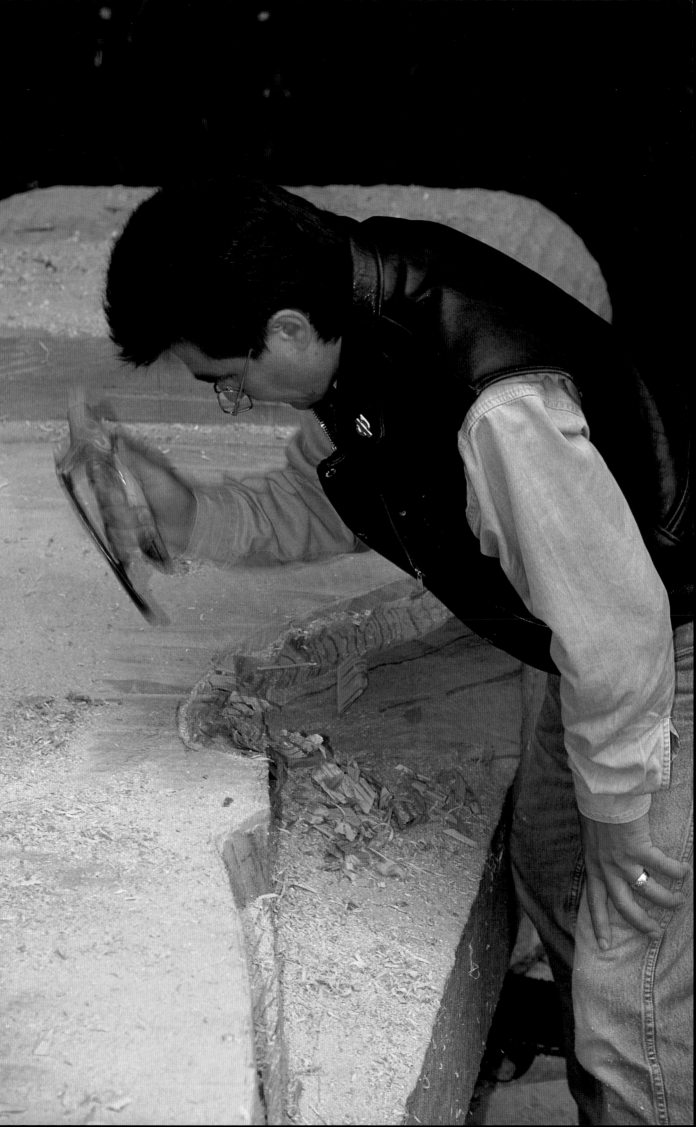

54

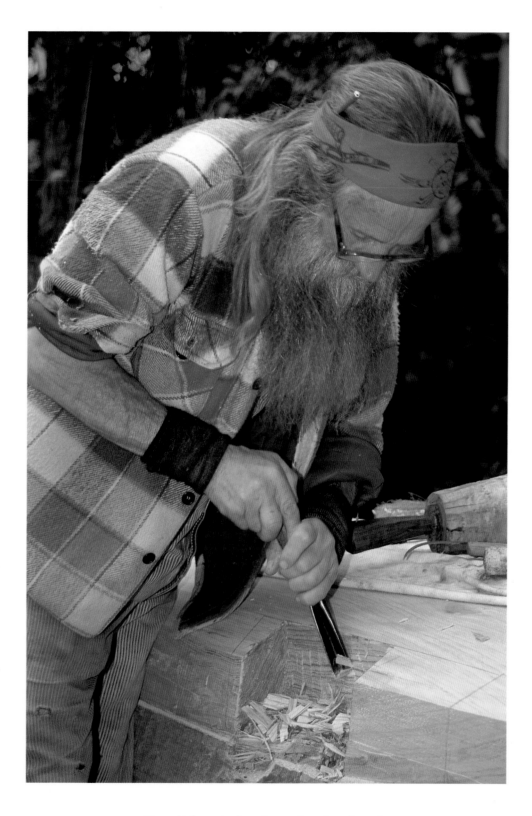

Henry chisels out the place where a salmon fin will soon be.

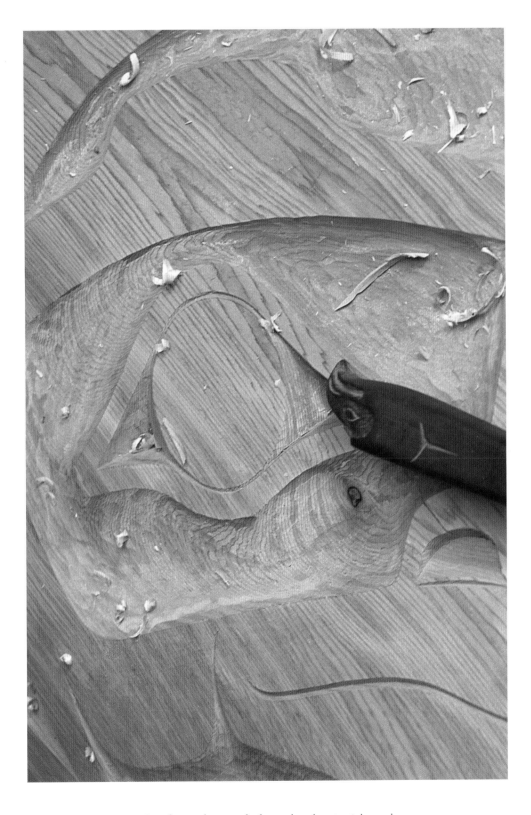

Detail of a salmon eye displaying the rich grain of the wood.

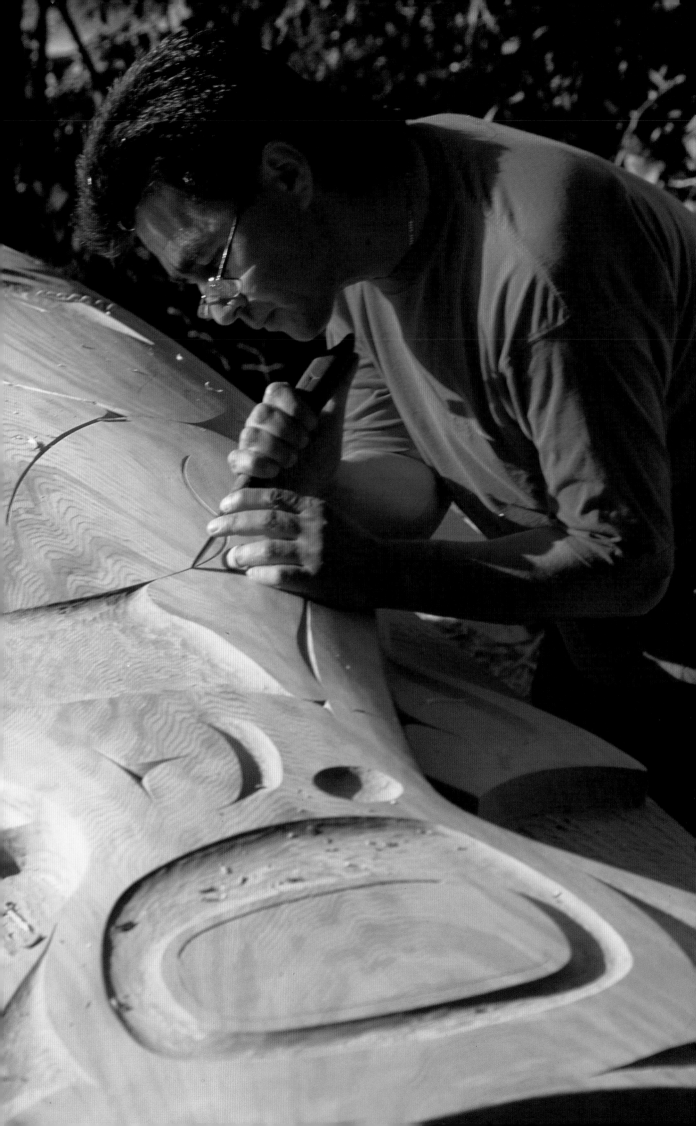

Colour and Balance

*This pole was a departure for me because when I carve I usually don't want to
paint my sculptures. But this pole was unlike anything I had ever done before. Our
traditional colours are red and black — the colours of life and death. And when I
think of it in those terms, colour seemed perfectly logical for the Salmon Legend.*

WHEN WE WERE beginning the Salmon Totem, Henry asked, "Do you think
maybe we should put a little paint on this one?" If it hadn't been for Henry's insis-
tence, there would be no paint on the Salmon Totem. For years now I have avoided
painting my sculptures. I have always wanted to carve more and paint less. I guess I
have always felt that the reason people paint their poles is because they are too lazy
to carve. Well, I am learning that that isn't always the case. It seems that in my mid-
dle age I am becoming more aware and that I am seeing the world in a different way.

So, from the beginning, I had reservations, if you will pardon the pun, about
whether to cover the beautiful grain of this tree with paint. But as I put the paint
on the cedar, I realized I wasn't covering the grain at all. The grain can be seen
through the paint. The areas of grain that are the hardest and shiniest stayed
shiny when the paint went on. The areas of the grain that were soft and absorbent
stayed soft and velvetlike when the paint seeped in. The paint sits on the top in

*Making a V cut with a
straight-edged knife.*

one area and becomes part of the tree in another. So two things were accomplished: the use of traditional colours and the preservation of the grain and life history of the tree. So I am happy I used paint. The areas around the salmon were left natural, so it has a balance not only between the red and black on the wood, but also between the painted and unpainted wood.

We worked in traditional colours of red and black. They are the primary colours used in traditional art on the West Coast because they were the easiest to come by. Black was taken from charcoal, while red came from ochre, from the earth. These colours are also indicative of life and death. Red, the colour of our blood, the earth, sustains us and gives us life. Black is the colour of charcoal and ashes where we all eventually end up. Red and black are living and dying. So using colour was quite a departure from anything I had done and yet it was so suitable to this subject of the Salmon Legend – the never-ending story of life and death.

In a strange way colour has played a pivotal role in my life. My favourite example comes from when I was 18 or 19 years old and I wanted to be an RCMP

Adze marks like so many fish scales.

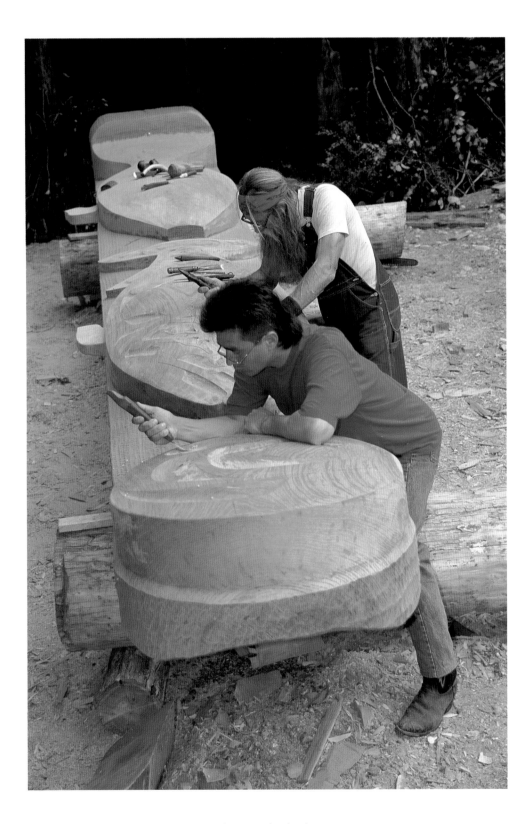

The totem pole takes shape.

officer and a member of the Musical Ride more than anything else in the world. In those days you had to be a perfect specimen of a human being in the eyes of the RCMP. You had to be over five foot ten and you had to be in excellent health — not a thing wrong with you. I went for my physical checkup and thought, I'm in good shape. I'm a young man in the prime of my life. I can run five or 10 miles without stopping. I'm not going to have a problem with this. Well, as it turned out, I was rejected. The doctor told me I was colour-blind. They discovered that I have a problem seeing red and brown close together. When I first heard that, I instantly remembered the problem I had always had playing snooker. I could never see the brown ball on the snooker table and always had to ask my opponent, "Will you please show me the brown ball?" Once it was pointed out to me, I could see the difference, but it was very difficult. So, in a strange way, colour has changed the course of my life. Instead of becoming an RCMP officer, I started down the path to what I am today, a (slightly!) colour-blind artist.

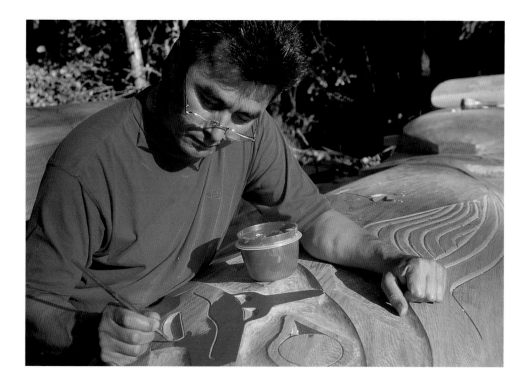

Above: *"If it hadn't been for Henry's insistence, there would be no paint on the Salmon Totem."*

Right: *Mixing paint: red and black are living and dying.*

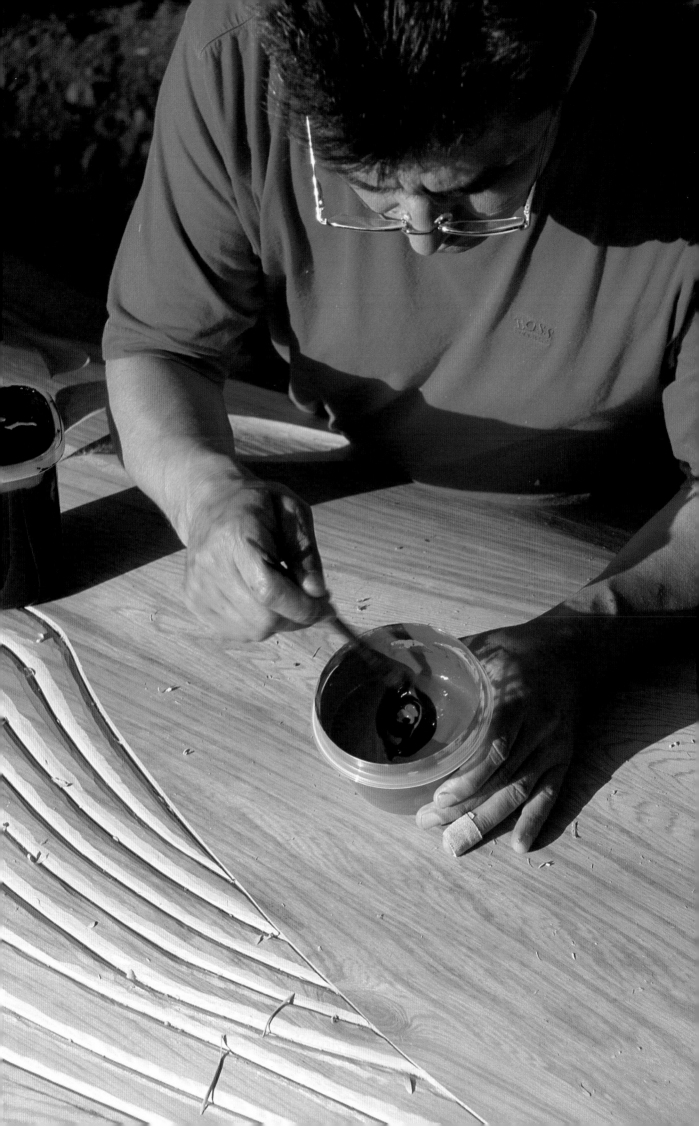

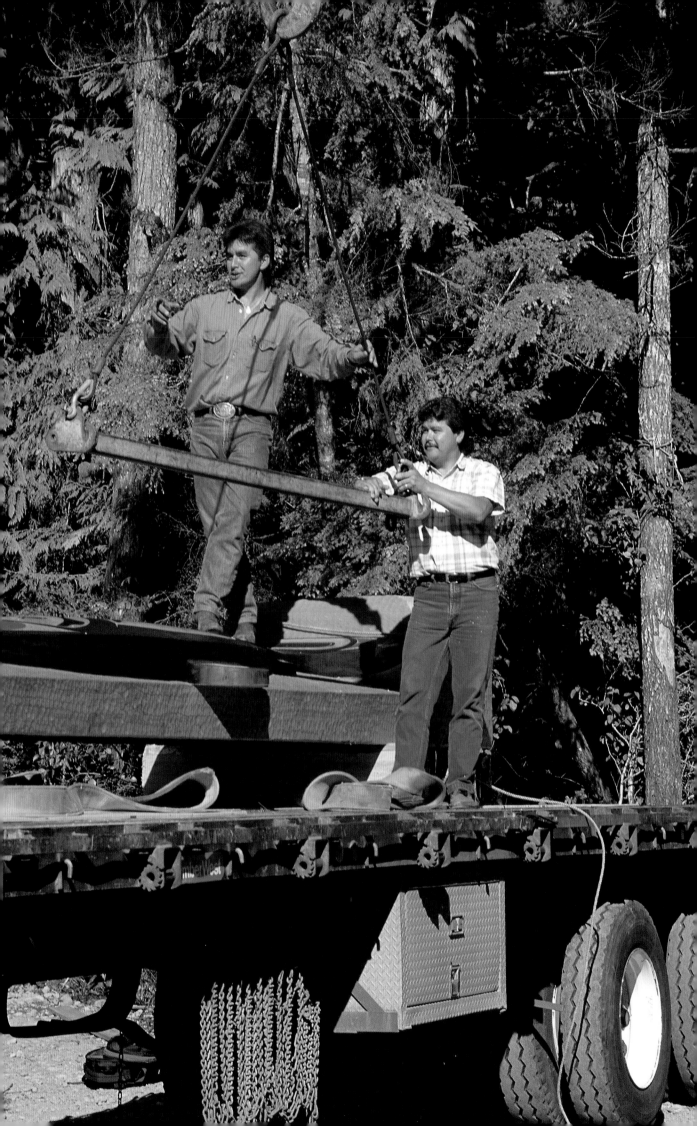

The Timeless Journey

*For me, the process of creating the Salmon Totem was a transformation. Part of me
came alive. I can still feel the fire burning inside. It burns stronger than it did
before I started. I was too caught up in the creation to visualize the raising of this
sculpture. I couldn't imagine the day it would rise . . . but I knew that day
would come and I looked forward to it with hope.*

I REMEMBER A VISION I had of the day the Salmon Totem would leave the site
where we were working on it and make that journey, that timeless journey, to
Victoria. It was like looking through a smoky glass or a fading dream. The pole
travelled from Nuu-chah-nulth land, the home of the Clayoquot people, past
Ucluelet and two different reservations in the Port Alberni area. All these com-
munities wanted to have some relationship, share some part of the journey, of this
Salmon Totem. And, of course, that vision came to pass.

As we approached the end of our journey with the Salmon Totem, I thought
of my aboriginal ancestors and the old people who say that time is endless and
that the life we live on this planet is very important. Our lives are very short and
we always need to do the best we can in order to be happy. Nothing we purchase,
nothing we can acquire in this world, will bring us happiness. The knowledge that

*Matt, my brother, and I help TimberWest
load the finished Salmon Totem for its long
journey to Saanich.*

we are being who we are supposed to be is what brings us happiness. So, for me, that journey from the Nuu-chah-nulth territory to Salish land was a timeless one. In moments like those, when I am in my truth, time stands still.

And somehow, somewhere, this journey will be recorded in stories. The legend will be told many times by people who perhaps would not have told it had that tree not died, had this artist not given some creativity so that the Salmon Totem would stand where it stands today.

Working with cedar, working with Henry, working to bring this legend to life was an incredible feeling, a strong feeling, a feeling of personal power that grew rapidly during that time. It was a year in which the tree itself had grown quickly, something that is exciting beyond the words I can use to describe it. What I feel now, what I am left with, is a connection to my ancestors that I had never felt before. Many things bring about this connection, this thread. Even the bark from the tree was pounded soft and woven into strands and ropes. These

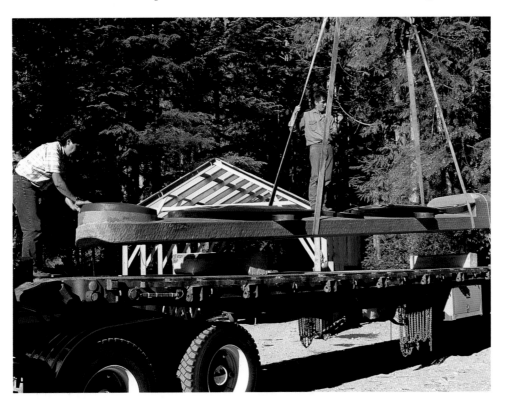

Lowering the totem ever so gently onto TimberWest's flatbed truck.

ropes connect me to my ancestors in strong bonds.

Just before we finished the Salmon Totem I was given the chief's name of Tlagwikila by the House of Walkus, part of the Owikeno people who live in Bella Bella, where my grandfather Henry Vickers once lived. During the summer of 1993, in the gifting of a copper to the chiefs of my grandfather's village, I didn't realize what would happen. But through this experience I was to connect myself to my grandfather and his people in a way I never could have done before.

The name Tlagwikila was given to me by the hereditary chief of the Owikeno and literally means "wearing a copper on his back." A copper is a shield. It is the most powerful symbol of wealth and influence among the people of the Northwest Coast. A copper is the identity of a family wrapped in a material object, a shield. With the gifting of the copper to the chief, I wanted to honour the people from whom my grandfather had come. Not only did I want to give to the chief a copper to honour them, but the copper was also to signify the spirit of Henry Vickers returning to his home of Bella Bella.

When the time came to move the Salmon Totem to its final resting place, the place of its rebirth, our first stop was in Port Alberni where we were welcomed by the Sheshaht and Opetchesaht peoples. Then we stopped in Cathedral Grove. The Nanoose people were there, the elders and youths. We walked through the forest with the elders and the children danced. From there a Penelakut man guided us to Nanaimo and then to Cowichan. We were met at the Native Heritage Centre by the chief and representatives of the Cowichan and the Malahat peoples. The final stop was the site of Saanich Commonwealth Place. The Salmon Totem lay there for three days, and on the fourth day, the Songhees were asked permission to raise the pole on their land, and permission was granted.

Before the Salmon Totem was raised a second name was added to the first one I had received. This second name was given to me by Simon Charlie and the leaders of the Cowichan people. Simon is an elder carver who has been a great influence on my life through his encouragement and support for more than 30

years. He gave me the name Hulhulanugh, which is the name of the first person who put things down on paper so people could understand. He gave me that name to honour the journey of the Salmon Totem.

I felt honour in receiving these names. What I didn't know at the time was the responsibility I had in accepting them. I didn't know how much a part of me was prepared to be responsible. It feels good and it feels strong. The receiving of these two names marked yet another transformation in my life.

When people saw the Salmon Totem being carved in Tofino, they saw Roy Henry and Henry Nolla. But something else was happening, something they couldn't see. Roy Henry and Henry Nolla were joined by Tlagwikila and Hulhulanugh. And Tlagwikila and Hulhulanugh were singing and dancing along with Roy Henry and Henry Nolla when the pole came to life. This process of receiving the names and making the journey with the Salmon Totem connected me in a new and stronger way to my roots and to my ancestors.

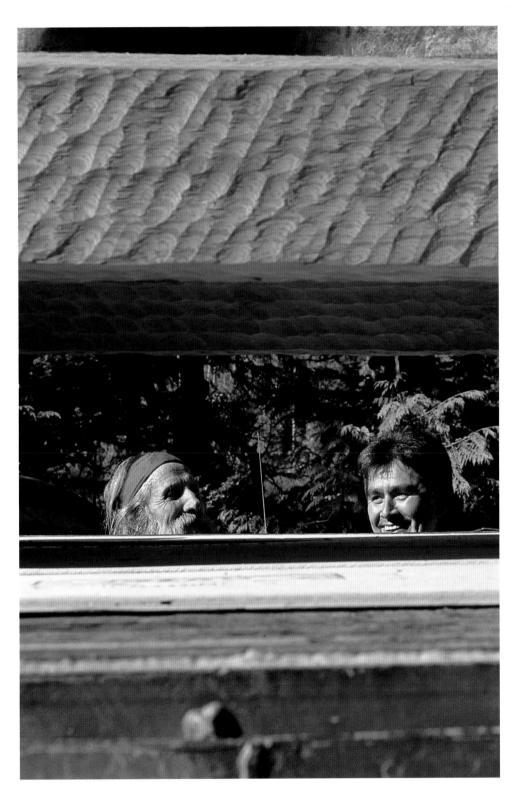

Henry and I relax, knowing we have both accomplished what we set out to do.

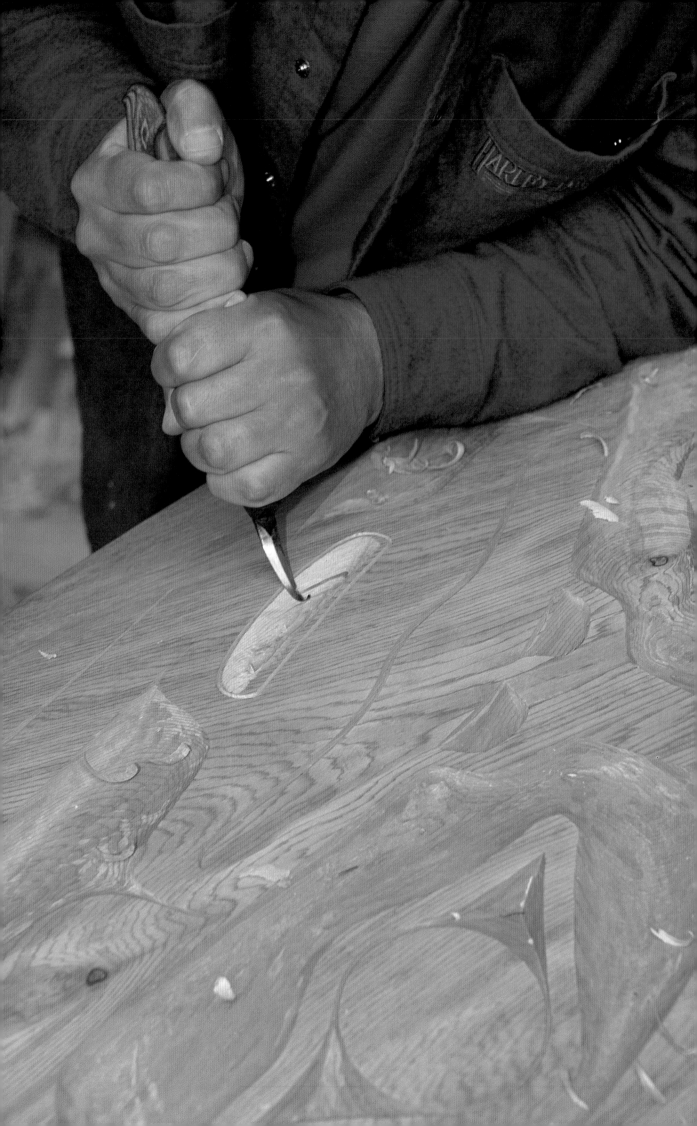

Spirit Transformed

When I am in my creativity, when I am "on it," as the contemporary expression
goes, when I am doing what it is I know I should be doing at this very moment, all
time stops and eternity casts its shadow. The passage of time becomes something that
doesn't exist. I am lost in all that thought, in all that mysticism,
in the spirit of creativity.

FOR ME, THE JOURNEY of the Salmon Totem wasn't easy. I was fortunate to have had the help of family and friends. Sometimes that help may seem small in the overall scheme, but it means everything to me.

I have so much to be thankful for, so much to give back. Just two years before I began work on the Salmon Totem I was battling an addictive personality, engaged in an ongoing fight with alcohol. In my work you can see the struggle. I sought refuge in the beauty of the natural environment around me and that became the focus of my art. When I finally confronted my problems and saw where I had gotten off track, off the good road (the "red road," as aboriginal North Americans call it), I was able to look at life in a different way. Now, and over the past few years, I can see people and family in my work. Like the Salmon Totem, it is all about returning, coming home again. Today I walk in truth and power.

"The little boy who used to smell the cedar and
watch his grandpa carve and be amazed was
astonished that he could do such things, too."

During the journey of the Salmon Totem, I often thought back to that ceremony held in the forest before the tree had given up its life, and to the words of the man and woman who had conducted the ritual. I felt at the time that it was a great privilege and joy to stand there and listen to people who were walking on the land of their ancestors and giving respect to the tree. For me, it was more than a privilege – there was a feeling of awe and honour. Not only did I feel as if I were being honoured, but I felt it an honour to be in the presence of spiritual people who were having a funeral for a forest giant that had grown from the bones of their ancestors. These feelings prompted me to think, Is this all I'm doing? They are giving up part of themselves and all I'm doing is carving. Is it enough? That was my concern throughout the entire journey of the Salmon Totem. I doubted that my contribution was going to be enough, that *I* was going to be enough.

Over the course of that journey I was especially honoured and privileged to

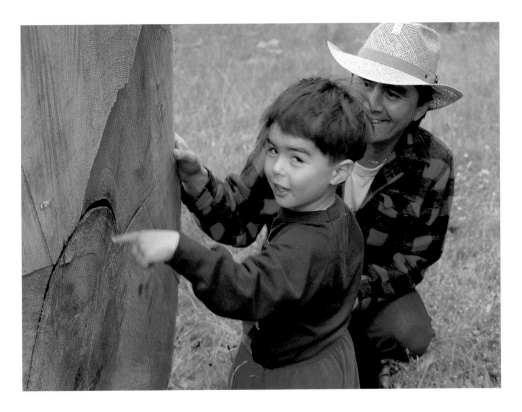

This is what it is all about — to teach, to see somebody else take the ball and run farther than I have, farther than I ever could have. Perhaps my son, William, will one day do just that.

have a friend in my four-year-old son, William. He helped me with those insecurities more than he will ever know. At the end of one day when we were working on the pole together he told his mother that when he grew up to be as big as his cousin Matt, he was going to help his dad with the pole. He was really going to help me because he was going to be bigger and stronger. To see this little boy, with this love and happiness and desire to be helpful, was, and still is, a beautiful privilege.

My dreams and visions have a tendency to come together very quickly, then I scramble, try to reach out, and make them all come alive at once. It is as if I want to work on all of them before they slip away. When that happens, I get pulled out of the clouds pretty fast. Sometimes I feel I have bitten off more than I can chew, which can be a little overwhelming. With the Salmon Totem the greatest difficulty for me was just allowing it to happen and not making it more than it was. I had to remind myself over and over that it was just a pole and that we couldn't know all the story because we were just a small part of that big legend. Just letting myself be a part of the process was the most difficult challenge for me. Could it really be that simple? Just carve two fish and a moon on a pole? Just be myself? It couldn't be that easy. It seemed too simplistic, too childlike. At the time I thought I was missing something.

On one of those days William came to me. I was sitting alone on the downstairs steps of my home in Tofino. He came over and sat down beside me and I hardly realized it. All my insecurities were rolling around in my head. But he sat there and, gradually, I felt his presence. Then he asked, "How are you feeling, Dad?" I told him that I felt a little pain. "Why?" he asked. Then I told him that I felt as if I were overwhelmed, that I had tried to do more than I should have. I told him I didn't think I could do it. "You can do it, Dad," he insisted. "I know you can." Later that night, just before he went to sleep, he said to me, "Dad, you're my best friend." That really hit deep. It is moments like these that help bring everything into perspective. Those moments tell me I am in the right place and that everything will be okay.

So, in the words of my young son, my friend, the message had come to me: just design and carve this pole. It really was so simple. All the stressful things — the planning of the final journey, the logistics, how it was going to be raised — were just details that would happen. My job was simply to carve and work on the pole, to show my boy how the grain grew and let him paint part of it. It was for him. It was about being with him in the moment, in the here and now.

To be there carving with Henry, with William crawling all over the pole — that is why I do what I do. Too often we wind up sharing space instead of time. That is why it is so difficult for us to see, to keep our vision today. All I need to do is be in the moment of creativity. The most beautiful thing in the world is sharing that moment . . . sharing the being in creativity.

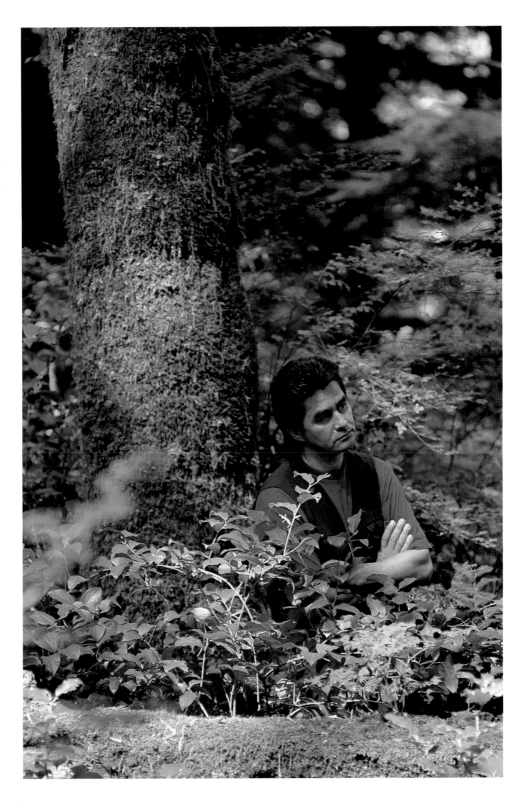

In a contemplative mood, leaning against a Sitka spruce. My dreams
have a tendency to come together very quickly.

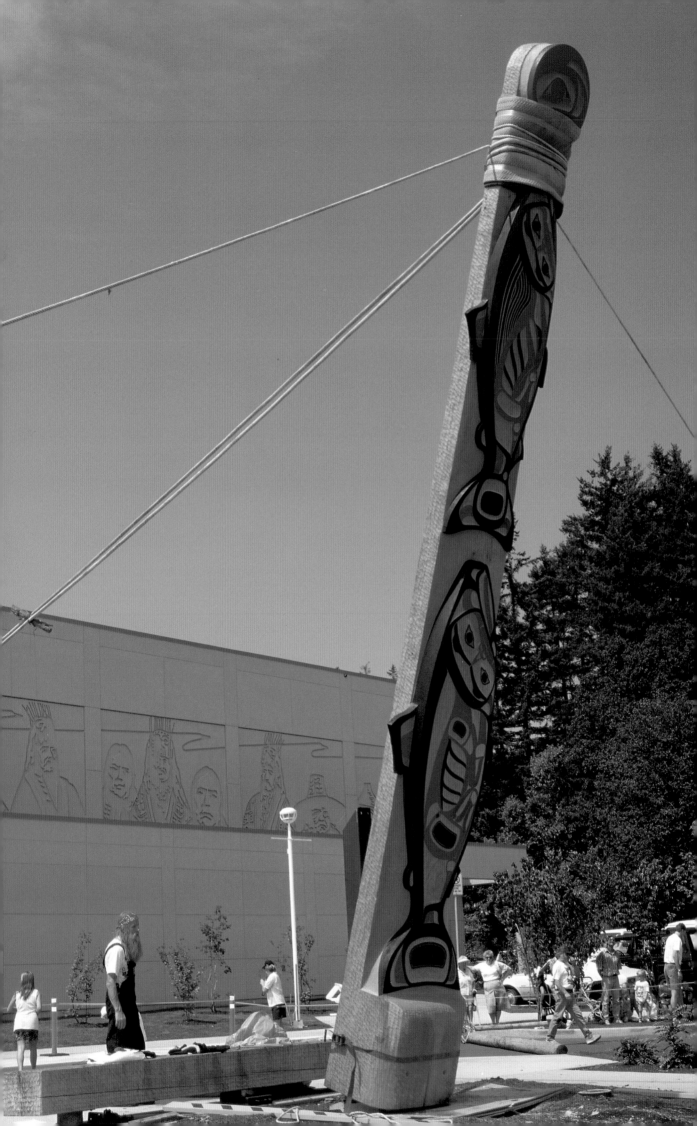

The Dance of the Carvers

For years, since the first idea for the Salmon Totem was born, I had looked forward
to the day the pole would stand completed and I would be allowed to give honour
and respect to the Salish people.

IT JUST WOULDN'T have been respectful to use a crane. So, out of respect for
the tree and the ceremony, we raised the pole in the traditional way – with ropes.
It was important to me to have it put into place by human hands. There were four
lines pulling the pole into place, and everyone who grabbed a rope wanted to be
part of the experience, to share in the birth of the Salmon Totem. It was impor-
tant to welcome these people and their desire to take part. It was good medicine.

There was music and singing. Then came the Dance of the Carvers. We had
necklaces with some of our tools – pencils, knives, and adzes – around our necks.
At first Henry was reluctant and started to dance stiff-legged around the pole. I
joined in and lost all sense of time and place. We were supposed to dance around
the pole four times, but by the fifth time, I realized I was in that place again, that
shadow where time loses its power.

There were drummers. They told me they had somehow forgotten all but one
of the drums for the ceremony. I said to them, "Then you are only meant to have

Raising the Salmon Totem at Saanich
Commonwealth Place, with the chiefs and
elders of my nine-panel frieze looking on.

76

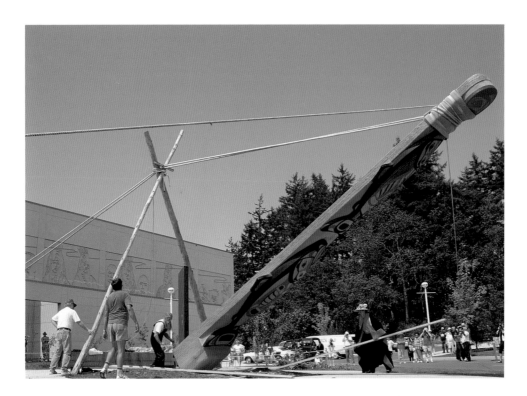

It was important for me to have the Salmon Totem put into place by human hands.

one drum." They used the one drum and it was good. There were dancers from the Solomon Islands. These aboriginal people from the other side of the world were there, showing respect and honour, dancing a tribute to the pole and to the people on whose land the pole stood. They said they were only going to do one song. I think they did five or six. It was beautiful. Speeches were made. I spoke. I can't remember any of it. I just hope my gratitude and respect for the people who had helped, the people who had supported this journey along the way, showed in my words. I think it did.

There are things that move you to the point of tears and you don't really know why. But the tears feel good and you know that they are supposed to come. Sometimes I think it is because you can't hold all the joy inside and it has to come out somehow. Just like sadness, joy can come out in a tear.

The winter of our discontent is gone. And, for me, the time of being a victim of wrongdoing is gone. It is not time to be a victim anymore. It is time to be a leader; it is time to be a supporter. It is time to show others that it is possible to come through everything we have endured and, in the words of Chief Dan George, "to build our race into the strongest, proudest segment of our society."

And so, with the birth of the Salmon Totem, a journey came to an end that had begun eight centuries ago when that cedar had first sprouted in the good earth of the Pacheenaht people. It was joyful and sad at the same time. When you think of living, if you are centred, if you have achieved that balance, you feel both joy and pain. It is a balance of life and death, red and black. I think that is where those tears of joy come from.

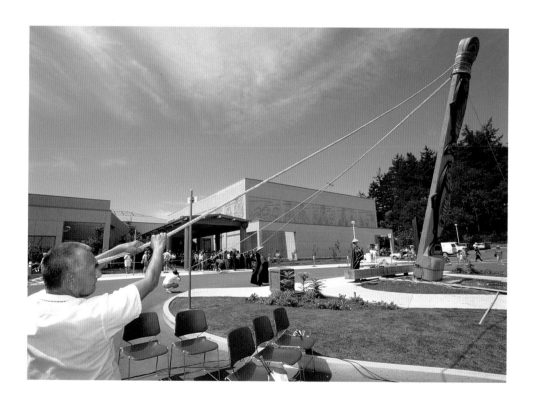

Almost there: the long journey of the tree into totem will soon be over.

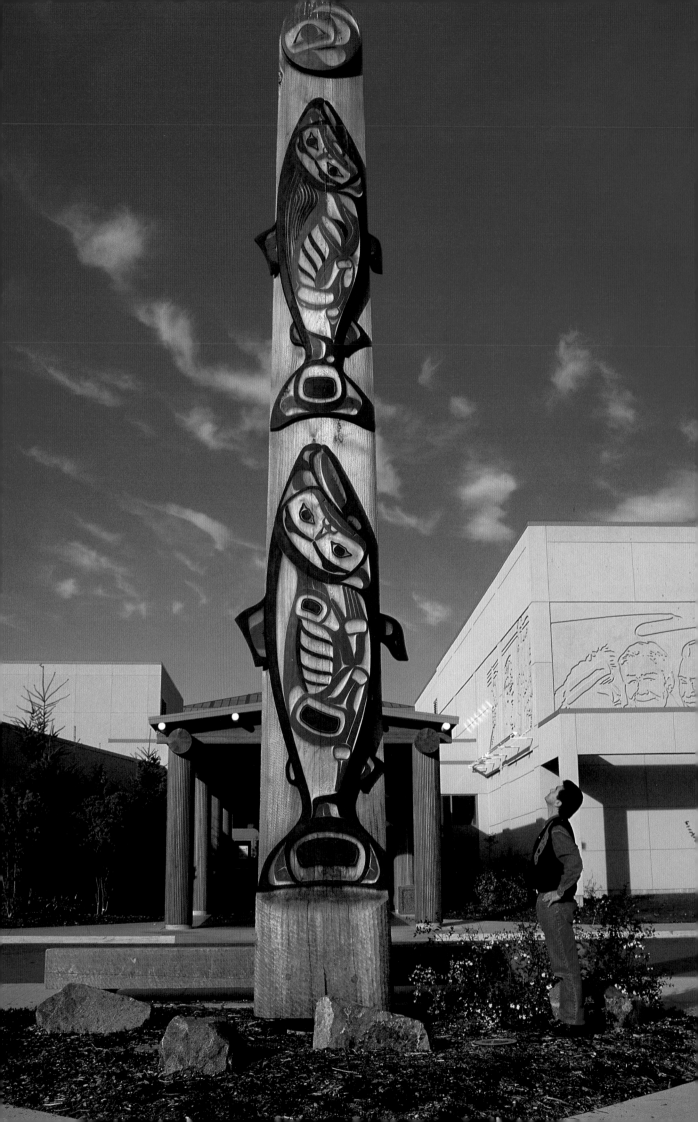

Afterword

MUCH THAT IS challenging and rewarding has happened since the completion of the Salmon Totem. In particular, I have printed eight new serigraphs and completed the painting *Sheep Standing by Himself*, which resulted in $150,000 being raised for Vision Quest, our bid to build an addiction centre for British Columbians.

Among my numerous works-in-progress is an exciting project that takes me back to when I was a six-year-old boy. At the time, my family was living in Kitkatla, an isolated coastal village without electricity and separated from the nearest town by a five-hour boat ride. Growing up in Kitkatla, I learned to look to the natural environment for fun and adventure. There were few visits to our village that were unexpected or unknown, yet I remember a lot of excitement surrounding the surprise arrival of a dark grey ship that carried the name RCMP ML 15.

The strange and wonderful men who came ashore brought a generator and a 16-mm movie projector to our community hall. They told us about the peacekeeping duties of RCMP constables and the rigorous training they had to undergo. We saw movies about their training camp and how they trained their dogs. I particularly remember one segment in which the men were working out in a swimming

As Chief Dan George once told me, "Those whose lives are lived in the forest, close to Mother Earth, know the secret life of a tree." Here the elders of my people gaze with me on what the cedar has become.

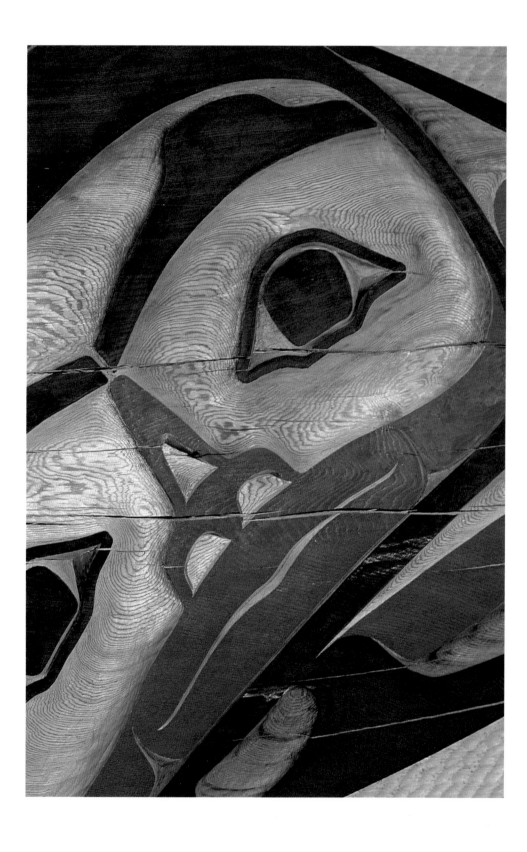

pool. The projectionist stopped the movie when the diver hit the water and then reversed the film to make the diver return to the diving board. This trick left myself and the other children awestruck. When the RCMP departed our cove, they left behind many dreams and visions, and instilled in me a lifelong affinity for the Mounties. I am currently working on a painting to capture this vivid childhood memory.

Another exciting development unites two men who have shared a very similar journey: my brother Art and myself. Born 14 months apart, Art and I played and grew up together on the beaches of Kitkatla. As we entered our teenage years, competition caused a rift between us. However, the sadness of growing apart has now been overcome by a desire and commitment to be together and to work with each other. Art has always displayed the same gift of creativity as I have and occasionally, in the past, we have collaborated. With this new work we are making a statement of unity and brotherhood. We have shared similar experiences and see many things in nature with the same awe and excitement.

Recently Art and I visited Bella Bella, the home of our grandfather, Henry Vickers. As part of that trip, Art and I returned to one of the places we frequented as children. We were both moved by the experience and soon started a painting that shows a rock formation in Principe Channel near Kitkatla. The rock looks like the fin of an orca. There is an ancient legend from our village that explains how this came to be, and we are working together to capture the magic of that legend in a painting called *Combined Vision*. On my own I am also working on three other paintings that deal with the ancient spiritual traditions and healing practices among North America's aboriginal peoples: *The Boy and the Sweat Lodge, Getting My Spirit Back,* and *The Journey.*

While this past year and a half has brought much success and joy, the death of my mother continues to be a profound loss. She was loved deeply by her family and friends as well as by the Kitkatla and many other First Nations people. Without a doubt she will be fondly remembered by those she met, taught, and

worked with during her life. To honour her, Art and I, as well as other members of our family, are creating a memorial pole in Kitkatla that will bear our totem, the eagle.

So, once again, I find myself carving a totem pole, one that ties me in a very personal way to the cycle of life and death and to the never-ending process of creation.

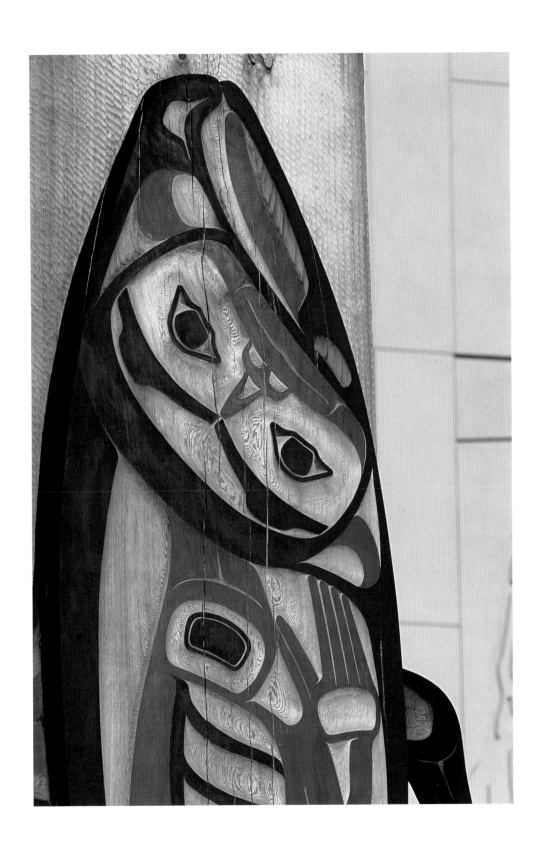